THE FLOWERING DESERT TEXTILES FROM SINDH

THE FLOWERING DESERT TEXTILES FROM SINDH

2nd edition

NASREEN ASKARI AND HASAN ASKARI

PAUL HOLBERTON PUBLISHING, LONDON
THE HAVELI, KARACHI: A MUSEUM OF TEXTILES
2024

For Iman and Sehr
and the yoke of tradition

2024

Revised edition of a book first published in 2019

The Hasan A. Foundation is a not for profit, charitable foundation in Pakistan which seeks to promote the arts of the country.
Its initial project is to establish a museum of textiles in Karachi, called The Haveli
www.hasana.foundation; office@hasana.foundation

Nasreen Askari is co-founder and director of the Mohatta Palace Museum, Karachi.
She has published a number of books including the seminal study on the textiles of Pakistan, *Colours of the Indus* (London, 1997).
Hasan Askari is a former trustee of the British Museum.

Text and photographs © the authors, 2024

ISBN 978-1-913645-57-1

British Library Catalogue in Publishing Data

A CIP record of this publication is available from the British Library

Produced by Paul Holberton Publishing
WWW.PAULHOLBERTON.COM

Designed by Laura Parker

Printed by Gomer, Llandysul, Wales

Front cover: no. 16, detail of a woman's head shawl, *abochhini*; back cover: no. 113, details of a spread, *khes*;
page 2: no. 5, detail of a coverlet, *roomal*; page 4: no. 79, detail of a dowry bag, *bujhki*;
page 9: no. 29, detail of a woman's head shawl, *odhani*

CONTENTS

ACKNOWLEDGEMENTS

This edition is, substantially, the same as the previous one of 2019, but with additions and revisions especially in the description of the objects. The hope is that this will make the listing of the objects more accurate and detailed both in terms of dates and iconography. The pursuit of authenticity in objects with an anthropological context can be an imprecise science and we have revisited our initial understanding over the past four years. Our revised thoughts are reflected in this edition. There is also an expanded and much more comprehensive glossary which should assist both student and casual reader alike.

An enterprise such as this, spread over several decades and covering the expanse of Sindh, from Kashmore in the north to Karachi in the south and Kirthar in the west to Kasbo in the east, has meant that our meanderings have touched numerous lives, far too numerous to list and thank individually. To all those who remain nameless here but from whom we have learnt and understood, our profound thanks. Without the generosity of the dozens who came forward, willingly and unreservedly, to share and to explain, this volume would not have been possible.

To the trustees and colleagues at the Mohatta Palace Museum, our gratitude for having withstood with forbearance the endless demands and countless revisions we imposed upon them. We would like to thank Akbar Khushik and Aziz Soomro who assisted us throughout in photography and identifying images in the book. Fareeha Nanjiani was unfailingly cheerful throughout the process.

Master craftsmen, Rab Dino and his family from Badin, Shafiq Soomro in Matiari and Shahid Hussain in Sobho Dero were always encouraging and Master Karamullah Memon from Hala taught us the intricacies of weaving. A surprising addition to our ranks was Javed Odho, now a senior police officer in Sindh, who facilitated our movements in Thar. Information on Meghwar embroidery was provided by Ashok Kumar Maheshwari and Kishore Jagdish Maheshwari as well as by Apa Yasmin Zubaidi and Zargul Brohi, all of whom took us through the techniques of the all-important *hurmitch* or interlacing stitch.

Dr Nabi Bakhsh Baloch, with his commitment to writing and research, was a source of continuing inspiration, but it was the late Dr Harchand Rai of Umarkot who first drew our attention to his extraordinary collection of Sindhi jewellery and textiles. Friends at the Sindh Provincial Museum in Hyderabad, Mumtaz Mirza, Zafar Kazmi and Khan Muhammad, all sadly now departed, taught us about craftsmanship in Sindh.

Others who helped us along the way include Babar Akhund, Sheikh Abdul Rehman, Rashid Soomro; Junaid Ahmed Abro and Syed Iftikhar ul Haq Hashmi were diligent in their assistance.

A final word of thanks to all those at Paul Holberton Publishing for having kept the faith in this book, which has resulted in a revised edition and with luck, many reprints to follow!

Karachi, March 2024

A TESTAMENT

Where did it all begin, this interest in craftsmanship that grew into an obsession and finally, a vocation? The answer is elusive; it could be my childhood trips to the family factory in Jhudo, replete with sacks of snow-white cotton on camel backs and the vibrant colours that the Jat women wore. Or could it be the memory of my mother carefully threading a needle to embroider my sister's blouse?

My mother taught me to admire and marvel at the needle. She always took pains to explain to me the significance of a stitch in embroidery and that each stitch was singular and personal. Her descriptions helped me to grasp how simple stitches brought together could create a pattern, and that these patterns had taken hundreds of years to evolve and may have been the first expression of what a woman considered to be a symbol of her modesty. Gradually, this convergence led to pride in a woman's appearance and, as patterns evolved, she froze them without a name. This was possibly a woman's first attempt to depict nature in the form that her mind perceived it.

The origins of embroidery have not been fully researched, but as isolated individuals drew closer and communities evolved so did the art of decoration. Painted Greek vases depicting embroidered garments dating as far back as the seventh century BCE have been found. Scythian embroideries from the fifth century BCE reveal the progress of stitches from simple to lavish needlecraft. From the Byzantine era to the ancient Chinese, from Persian to South Asian cultures, numerous examples of textiles reflect the influence of plants, floral motifs, geometric patterns and stylized forms of life. Embroidery has been used as embellishment, for identity and for religious and ceremonial purposes since time immemorial.

Time moved on. I left the cloistered surroundings of an elite school in Karachi for an entirely alien environment in Jamshoro, then a distant suburb of Hyderabad with few signs or symbols of a modern city. I was exposed to a kaleidoscope of people from the hinterland of Sindh, disparate communities from different areas, some very colourful and some not so, but all close to nature and with an unshakeable faith in destiny.

My first Sindhi blouse front or *gaj*, which I still cherish, was purchased in Hyderabad from a young lad who now has a shop in Karachi and is a major supplier for dealers abroad. The *gaj* itself was unsubtle and, possibly, gaudy when compared with the prevalent Karachi couture, but I was drawn to it for its raw colours and bold forthright design. Why remains an unanswered question, but since then I have travelled to many corners of the world admiring local crafts, discussing and relishing what I have seen and trying to curb an insatiable urge to possess the best embroidery. My passion remains unquenched as there is always a better piece elsewhere.

I gradually learnt to discern distinctive patterns from community to community, area to area, and how they evolved. I discovered that the pillage of the modern world had not yet corrupted the men and women whom I met and who practiced traditional stitches. I marvelled at their excellence in producing works of art with precision and without any formal instruction in space, colour or scale. They embroidered by instinct, heralding a tribute to their

mothers who had taught them this art as an essential part of their upbringing. Motifs to them were sacred, innovation was not.

Some common motifs are known by different names in different areas. Meghwar groups have different names for the same motif. Motifs tend not to be fixed, as most of them are regarded as objects in nature and some are introduced inexplicably, such as the cauliflower or *gobi* in embroidery from Thar. When quizzed how they could depict a flower or a plant (such as the cauliflower) which was not indigenous to their area, one ninety-year-old retorted that she had learnt this from her mother who in turn had absorbed it from her mother – but it was most certainly their motif since the time the Hakro river irrigated the land.[1]

Uneducated though they may be, these women were culturally sound and down to earth, which made them highly sensitive to their environment. They could discern the cosmic code in the order of the universe, the sun as a perfect circle, the waning and waxing of the moon, the passing of time. These ever-changing cycles in nature influenced their lives and rituals. They have their own rustic wisdom to decipher order in nature and work in harmony with the vertical, the horizontal, the circle – the primary grids in their embroidery. The triangle and the square are the other inspirations. These primary shapes stem from their ancient belief that from the circle, a perfection of wholeness, emanate all forms and patterns in nature.

When they add motifs to patterns, there is remarkable consistency in their placement; there is a point from which the cursive motif originates and there is complete balance, discipline and rhythm in the flow of the needle. Embroidery becomes a universal language.

When I asked a Meghwar woman what inspired her to choose colours, she gave me a reply that has stayed with me ever since. "*Indlath*" – the colours of the rainbow – she said. How true! If an object could give so much delight to feel and possess, how much more pride must it have provided its creator?

Much has happened since that first spontaneous and inexplicable purchase in Hyderabad. I have spent a lifetime in pursuit of the stitch even more skilled than the previous one. This quest has defined my life, with time spent at the Victoria and Albert Museum, London, and the National Museum of Scotland, Edinburgh, and my role as the founding Director of the Mohatta Palace Museum in Karachi since 1999. The past twenty-five years have opened up avenues of joy and discovery, a tapestry of journeys tracking the path of the needle.

This book is based on some of the textiles of Sindh in our collection, from its desert, delta and hilly regions. The collection began in 1970 and has been sustained by us for nearly fifty years. It is not just a list of objects; it is a tribute to the people of Sindh, and to the vibrancy of their traditions in the face of every adversity.

NOTE

1 The Hakro (also known as the Hakra) flowed through the Thar desert and dried up, according to some sources, in approximately 1900 BCE. Some scholars regard the river as the Saraswati mentioned in the *Rigveda*.

TRADING PLACES

Have we not Indian carpets dark as wine,
Turbans and sashes, gowns and bows and veils
And broideries of intricate design,
And printed hangings in enormous bales?
James Elroy Flecker, *The Golden Journey to Samarkand* (1913)

Sindh, as an outcrop of British India, was to a certain extent marginal, under British rule, to geopolitical considerations. This was exacerbated by its inclusion in the wider Bombay Presidency (until 1936) and therefore its significance as an area at the crossroads of a number of trade routes was not always appreciated. The trading traditions of the region go back to medieval times and the region was described at the time of the Arab conquest (711 CE) as "the hinge of the Indian Ocean trade as well as the overland passway".[1]

There is evidence that Sindh was part of a network of trade routes from the Indus through Central Asia as early as 200–300 BCE.[2] The historical relevance of Sindh going back to before the Christian era and through the Middle Ages has been documented elsewhere.[3] Given the topicality of trade routes today with debate and discussion centred around China's ambitious 'One Belt One Road' initiative, described in one contemporary analysis as "the present and the future of the world",[4] it is particularly interesting that Sindh had its own version of 'One Belt One Road' several hundred years ago.

Sindh, like anywhere else, has its share of fables, foibles, follies and flights of fancy. For instance, the fine linen shroud in Turin, known as the *Sindone*, that was allegedly wrapped around Jesus following his crucifixion, has been supposed by some, because of the similarity of the names, to have originated in Sindh.[5] While we regard this claim as far-fetched, what is not disputed is that there was an active trade between the ports of the Indus delta and Basra (and subsequently goods would be transported further afield).[6]

The Achaemenid empire (550–330 BCE) extended as far as the Indus and, possibly, beyond. The area is described in Old Persian inscriptions as 'Hindus' (the etymological equivalent of 'Sindh'). Trade was the principal imperative, which supports the contention that there was considerable interchange between the Indus and Mesopotamian valleys.

We are aware that the large sophisticated cities of Mohan Jo Daro to the south and Harappa in the north that thrived and perished along the banks of the River Indus excelled at growing cotton, indigo and a variety of other crops. Archaeological finds from Mehrgarh in Balochistan dating to the seventh millennium BCE provide us, in one of the grave sites, with evidence of woven cloth together with large finds of cotton seeds datable to the fifth millennium BCE.[7] The settlement at Mohan Jo Daro, c. 2500 BCE, produced fine cloth, used vats to dye garments and needles to stitch fabric. A trefoil motif in relief on a garment draped around the shoulders of a nobleman is a significant find.[8] The sculpture confirms that patterned cloth was in use in the Indus Valley at this time. Modern-day historians accept that this region had a well developed local industry, with contact and exchange between neighbouring settlements.

Viewed in the context of the documented existence of a cotton weaving tradition and the established coastal trade between Sindh and the Persian Gulf, the claim about Jesus's shroud may not be as outlandish as we had originally thought. But we continue to believe that the conjecture is driven by the phonetic proximity of Sindh and *Sindone* (though the word *Sindone* has Aramaic roots, and could be of Levantine origin).

A Rabari girl wearing traditional ornaments.
Virawah, Nagarparkar, 2008

RIGHT The joy of the hearth. The printed pattern on her garments is akin to traditional embroidery. Outskirts of Umarkot, 2017

In more recent times, because of its strategic position, Sindh became the focal point of several trading routes. It is not immediately obvious that by the 1930s Karachi was the third largest seaport in British India (after Bombay and Calcutta), fostered and promoted, initially, by the Hindu trading class and later adopted by the British. But, in addition to maritime trade, there were several caravan routes that criss-crossed the region. The most important of these was the north-south axis between Karachi and the cotton and grain markets of the Punjab. But the west-east routes were just as important and, potentially, more interesting, as they straddled different cultures. Central Asia was accessed through Quetta and Kandahar with Shikarpur as the pivot; a subsidiary route from Persia went through Hyderabad and Umarkot to Rajasthan and beyond. Somewhat less well known is the opium trade between India and China, which was routed from Malwa (in Rajasthan, where it originated) through Karachi to China.

Sindh, therefore, was the nexus for a number of influences – the Punjab and further afield to Kashmir and the North West Frontier, to Persia and Iraq through the coastal trade between Karachi and the Persian Gulf and to Central Asia through the traditional caravan routes. Trade routes were common enough across the world but what gave Sindh a particular singularity was its strategic siting and the multiple access it enjoyed. There were the sea links, the established north-south route which extended to all of undivided Punjab (which meant till the gates of Delhi) and Kashmir – and the two westerly routes with pivots in Shikarpur and Hyderabad. There was no other region in all of pre-partition India that came close to rivalling Sindh in this respect. Only Punjab

LEFT A Baloch girl on her way to collect provisions. The neck opening to the right on her *kurta* indicates she is a Muslim. The *hurmitch* or interlacing stitch can be seen on her sleeves and *kurta*. Naing, Kirthar 1996

RIGHT A hamlet in Thar

was in contention with access westward through the Khyber Pass to Central Asia. But there were no seaports in the Punjab and the links with Persia and the Arab worlds were tortuous through Multan. But, even in this case, Multan, in the south of the Punjab, is roughly equidistant between Lahore and the borders of Sindh. In any event, after repeated invasions, Multan lost its pre-eminence to Shikarpur in Sindh in the late nineteenth century. The importance of the seaports of the Indus delta and of Multan as regional trading centres has been largely overlooked by textile historians due to a pre-occupation with Surat's better defined role in the trade of the Mughal Empire and in commerce via the Indian Ocean. This, then, is the particularity of Sindh which has shaped its traditions – from crafts to music to its religious outlook.

The fact that Indian traders, Shikarpuri from Sindh and Pathans, ranged across Central Asia, down the east coast of Africa and into the Malayan peninsula has been the subject of extensive academic interest. What is not commonly known is that the Sindhi Sufi poet Shah Abdul Latif (1689–1752 CE) was extolling the virtues of cities across the known world in his poem 'Sur Sarang'. Istanbul, Samarqand, Byzantium, Kabul and Kandahar are all mentioned, as are the major trading centres adjacent to Sindh, Jaisalmer, Bhuj, Bikaner and, further afield, Delhi and the Deccan. That an awareness of Sindh's critical role in connecting far-flung civilizations should have permeated the consciousness of a reclusive and unworldly poet-philosopher as early as the seventeenth century is proof positive of how trade across frontiers was embedded in Sindh's public consciousness.

It was inevitable therefore, that designs, styles and techniques in textiles should transpose themselves from Central to South Asia and vice versa. An interplay of ideas is the stock-in-trade of civilization. But what is not always understood or appreciated is that Sindh was the fulcrum where the techniques of Central Asia and the Persian plateau were forged with the skills of local artisans. This evolution spread quite naturally, because of cultural affinities, trade links and demographic exchange, to adjoining Gujarat and Rajasthan, and many of the textile designs that are passed off as being of Gujarati or Rajasthani origin are in fact, Sindhi. This is not to suggest that the craftsmanship in one area is superior to the others, but simply to assert that, to the extent that designs and techniques in western India reflected Central Asian influences, they would have emerged in Sindh before moving further east.

Cultural diasporas are a common enough phenomenon all over the world but are particularly noteworthy in the Indian subcontinent. Artistic forms and trends exploiting affinities with neighbours and far-flung areas became localized. This contributed to a vibrant mosaic that looked beyond local tradition. The precise origin of weaves became obscure and rare hybrids in technique and motif evolved.

It is therefore not surprising that much of what Sindh has to offer in terms of textiles has been subsumed under an amorphous 'Western India' label. Gujarat and Rajasthan provide easier access, an established mercantile tradition and a concerted effort to promote their cultural distinctiveness. There is no embargo on cultural norms transposing themselves across geographies. The migration of communities inevitably led to the transfer of skills. But authenticity requires that when skills are re-deployed there should be a nod to the classical origins of the design or technique.

A case in point could be the geometric block-printed cotton cloth known as *ajrak*. Unarguably of Sindhi origin, it is now produced in industrial quantities in Bhuj in Kutch and, to a lesser extent, Barmer in Rajasthan. But not to identify the design and the technique as being of Sindhi origin could suggest an incipient artistic dishonesty. Designs, skills and techniques travel, origins do not.

NOTES

1 Wink, Andre, *Al-Hind: The Making of the Indo-Islamic World*, vol. 1, Leiden, 1990.

2 Johnson, Gordon (ed.), *The Cultural Atlas of India*, New York, 1995.

3 Askari, Nasreen, 'High Roads and Low Roads', in *Textiles from India*, Calcutta 2006, pp. 268–86.

4 Frankopan, Peter, *The New Silk Roads*, London, 2018.

5 Shah, Saiyed Ghulam Mustafa, 'Sindh – Some Glimpses', *Sindh Quarterly*, Karachi, vol. XXII, no. 3 (1994); interview with Dr Nabi Bakhsh Baloch, 'Sind through the Centuries', Karachi 1995.

6 Duarte, Adrian, *The Crafts and Textiles of Sind and Balochistan*, Institute of Sindhology, Jamshoro 1982.

7 *Mehrgarh: Report of the French Archaeological Mission to Pakistan*, Karachi, 1995.

8 Anawalt, Patricia, *The Worldwide History of Dress*, London, 2007, p. 217.

A COAT OF
MANY COLOURS

One of the unintended consequences of the partition of the sub-continent in 1947 was the mass migration of religious groups across the newly demarcated borders. There were five provinces of British India that were allocated to Pakistan; of these, two, Bengal and Punjab, were further partitioned to accommodate the substantial Hindu minority. A further two, the North West Frontier (now called Khyber Pakhtunkhwa) and Balochistan, had a very small percentage of Hindus (and, in any event, were not contiguous with the borders of India). That left Sindh, which was allocated in its entirety to Pakistan. The Hindus of pre-partition Sindh were clearly a minority (29.25% of the population)[1] but this percentage does not reflect the enormous influence that the Hindus had on Sindh before 1947.

The economic development of Sindh merits a brief explanation. Sindh had three large centres of trade and commerce. These were Karachi, Hyderabad and Shikarpur. Trade, commerce and finance were largely the prerogative of the Hindus and controlled through these three cities, most particularly Karachi as the most developed of the three and favoured by the British. This meant that urbanization of the Hindus was far greater than amongst the wider population (42.88% as opposed to 19.6%, province-wide).[2] This, in turn, meant that all three principal cities of Sindh had non-Muslim majorities (Hyderabad and Shikarpur decisively so with an almost equal split in Karachi).

The urbanized Hindus, both by virtue of their resources and their greater exposure to Western norms, sought and assimilated the prevailing aesthetic influences of society, especially from Bombay. Hence came the charitable endowments that Karachi has benefitted from or the ornate architecture of the *haveli*s in Shikarpur (though these were not exclusively Hindu). At the same time, there was a concerted effort to patronize artisans and a visible pride in the craftsmanship and artistic traditions of the province.

The Hindu trading class of towns like Karachi and Hyderabad also sought opportunities for exchange and commerce not just in the immediate hinterland but abroad. One of the goods for trade was 'Sindhi work', as it has been described – a collection of Sindhi craftsmanship in a variety of media but with a substantial emphasis on textiles.

An awareness of Sindhi craftsmanship as early as the second half of the nineteenth century is documented by Pierre Lachaier, who says that "locally made handicrafts described as Sindhi Works were very much in demand in Bombay ... these enterprising merchants, who were to be called Bhaibands, started to emigrate to distant countries to sell their merchandise".[3] The territories mentioned by Lachaier are Hong Kong, Singapore, Malaysia, Egypt and the Middle East. The relevance of this observation is that Hindu merchants, at least two hundred years ago, had become aware and appreciative of their Sindhi heritage and had begun to monetize this tradition. It is reasonable to assume that this involvement played a significant role in preserving the tradition of craftsmanship in the province till 1947.

There were two significant aspects to the contribution of the urbanized Hindus to the crafts of Sindh – first of all, as an emerging bourgeoisie with its attendant affectations as patrons

and promoters; secondly, as entrepreneurs and traders, seeking to diversify their sources of income and alighting upon Sindhi crafts as a vehicle.

Another group of Hindus who fostered an interest in and awareness of Sindh were the Amils. The Amils, while part of the Lohana ethnicity, had created a distinct profile of their own as a literate, culturally ambitious group, who acted as chief courtiers or *dewan* to the Muslim land-owning class. They schooled themselves in English, served the British in administering the province and rose to positions of importance in the courts of the landowners. In the process they distinguished themselves from the remaining Lohanas and created a cultural and aesthetic divide between them. These strands occupied one end of the spectrum.

There was another dimension to the Hindu population in Sindh. In addition to the urbanized class, there was (and, to a limited extent, there remains) a completely rural, cripplingly poor, largely disenfranchised group, known generically as Scheduled Castes (a generalization that covers a spectrum of ethnicities or groups), who were concentrated in the Tharparkar district. As this volume documents, some of the most skilled craftsmanship in Sindhi textiles is from this region. Tharparkar, unusually in 1941, had a population that was evenly divided between Hindus and Muslims, but Hindu artisans had a disproportionate influence on the style and symbols of this region. The craftsmanship from this region, while largely indigenous, was influenced to a certain extent by adjoining Rajasthan and Gujarat; in other words, unlike the urban centres, where patronage promoted the arts and crafts,

Tharparkar was a centre of skill and production. And the craftsmen were, to a significant extent, Hindu. These two factors, the urbanized Hindu merchant with the resources to collect and promote his local heritage and the impoverished Hindu with few skills except to replicate a tradition that had been handed down by his forbears, created an environment where the artistry of the textiles of Sindh could exist and thrive.

A brief digression on the ethnic origins of the Sindhi trading class may be appropriate. The urbanized Sindhi Hindu belonged to an ethnic grouping called the Lohanas. There are many versions of the story of how and where Lohanas originated, some mythical (including a claim that they founded the city of Lahore) but there is no doubt that this community, now scattered throughout India, were industrious, enterprising and, therefore, successful. The pride they took in their origins is evident even today, at least seventy five years after they migrated en masse from Sindh. The Sindhis in India have local associations designed specifically to retain elements of their identity. In addition, the cultural and charitable emphasis of the Sindhi Hindus is obvious in Bombay, where they have endowed cultural, educational and medical institutions.

An awareness of his geographical roots still permeates the Sindhi Hindu emigrant to India.[4] After all, if the historian Michel Boivin is to be believed, the concept of *Sindhiat* – a belief in the identity of the Sindhi people – is fostered to this day in outposts such as Bombay.

In spite of its historical internationalist outlook, in recent years there has been a marked closing of ranks within the community

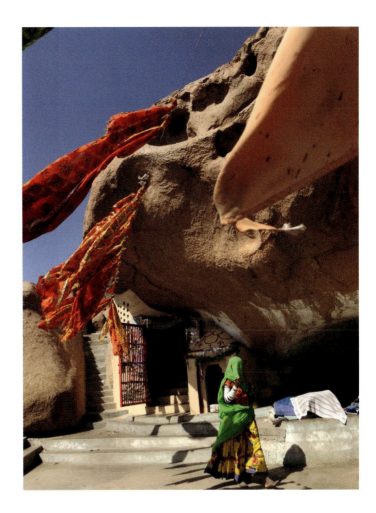

– so much so that, as recently as 2000, a historian noted that "Sindhi businessmen in a given country will always prefer doing business with other Sindhis in another country rather than non-Sindhis".[5] After it had been shorn of its hinterland, there was a particular urgency to these efforts and a desire to create a narrative around the community's distinctiveness. A particularly striking example of harking back to the past is the educational charity in Bombay called the Hyderabad (Sind) National Collegiate Board – the appellation 'Sind' added to make the distinction with the much better known Hyderabad in South India (which, ironically, is a significant bastion of Muslim culture). Founded in Sindh in 1917, it chose to move, lock, stock and barrel, to India in 1947 and now runs twenty-eight educational institutions.

In Sindh itself, Hindu philanthropy endowed a number of monuments in both Karachi and Hyderabad. Examples of these include the Dayaram Jethamal (abbreviated to DJ) Science College in Karachi or the Dayaram Gidumal sanatorium in Hyderabad. The Mohatta Palace Museum is also a reminder of Karachi's Hindu legacy, though in this case of Marwari rather than Sindhi munificence. Another example of cultural involvement is the song 'Damadam Mast Qalandar', which is an anthem in Sindh (and to a certain extent in Pakistan) first popularized by a Hindu singer, Bhagwanti Nawani.[6] Nostalgia for a past now irredeemably lost can be sensed in publications like the *Sindh Nama*, published in Bombay as recently as 2018.

What we seek to illustrate by pointing out this somewhat frenetic aspect of the community is a continued attachment to their geographical roots, their ethnicity and their cultural wellsprings. It is therefore much easier to appreciate how involved this community must have been in the artistic expression of the province at a time when they had both numerical weight and economic clout. This was particularly apparent with textiles, which to some extent were part of their stock-in-trade, but were also visible across the cultural expanse.

There are therefore a number of strands in the Hindu legacy: a commercial one identified very early on by the trading class that the artisans of the province could be a source of trade and profit; a social one, whereby the bourgeois Lohana class sought out the emblems of material success; a cultural one, with the Amils seeking to differentiate themselves from the petty bourgeoisie through a higher aesthetic; and, finally, the artisans themselves, whether Meghwar, Rabari or Kohli. All these communities with disparate but complementary approaches made up the rich tapestry of the textiles of Sindh.

A remarkable statistic quoted by Sarah Ansari of the University of London demands our attention in this examination of the role

of the Hindu in Sindh. The percentage of Hindus in Karachi in 1941 was 51%; in 1951 it was down to 2%.[7] The net result was that, post-1947, to a great extent, an awareness of the importance of the Hindu contribution to the artistry in Sindh evaporated. This is not to suggest that this was orchestrated; simply that the wholesale displacement from Sindh of the Hindus that could have advocated and articulated the message of the relevance of their community was almost total. Both the Lohanas and the Amils left almost entirely (Hindus, 29.25% of Sindh in 1941, were down to 7.5% in 2023).[8] What remained, except for isolated pockets, were the Rabaris and Kohlis, largely confined to Tharparkar, who eked out a bare existence and had neither the time nor the skills to represent their community.

Why was there such a mass flight of Hindus from the province in 1948? As documented elsewhere, in 1947 Hindus in Sindh were both significant in numbers and dominant in trade and commerce. One of the reasons behind the precipitate departure of the bulk of the Hindu population may have been fear of religious disharmony. But religious disharmony was endemic across pre-partition India and not necessarily a recent phenomenon. For instance, the *Chach Nama*, the oldest extant historical source on Sindh, states that the Brahmin ruler, Chach, imposed harsh restrictions on the Jats and the Lohanas (both Hindu denominations), forbidding them to use saddles or wear turbans, and compelling them to wear only coarse garments and to travel barefoot.

Similarly, following the conquest (c. 712 CE), the Arabs continued the repressive practices of the previous Brahmin rulers, and the former Hindu rulers (the Rai dynasty) were reduced to becoming artisans, primarily dyers, and the woman folk obliged to wear uncut cloth. This did not deter the Hindu population from continuing to live and prosper in Sindh. The demographics of the province changed following the Arab conquest. A process of migration and proselytizing meant Sindh ended up with a Muslim majority but with a substantial Hindu minority. In some respects this could be regarded as a tectonic shift, but it did not have a discernible effect on the newly created minority.

In colonial times, sectarian violence was much more prevalent in, say, United Provinces (now Uttar Pradesh in India) than in Sindh. There was no equivalent in Karachi of the 'Great Calcutta Killings' in 1946. But in spite of the riots in Calcutta (and comparable ones in Noakhali, now in Bangladesh, also in 1946) there was no wholesale evacuation of an entire community. In fact the Muslim population of West Bengal in 1951 was 19.85% and the Hindu population of East Pakistan 22%. (The Muslim population of West Bengal had increased to 27% by 2011. The Hindu population of Bangladesh, however, has declined over the years and was 7.9% according to the official 2022 Census. This is a significant – albeit gradual – decline in percentage terms, and is a function of economic migration rather than a flight to safety.)

There were riots in Karachi in 1948 but not anywhere near the magnitude seen in the Punjab or elsewhere in North India. So to what can we ascribe this large-scale flight?

The best guess is a sudden loss of confidence in the state and a failure of statecraft on the part of the new government. There is

anecdotal evidence for this. The Mohatta Palace in 1947 was the summer resort of the Mohatta family, who would escape the heat of Rajasthan for the balmy, seaside comforts of Karachi. In 1947, it was requisitioned by the Pakistani state to house the first Foreign Ministry of the country. Shivratan Mohatta, who was resident in the building at the time and was a personal friend of Muhammad Ali Jinnah, remonstrated with Jinnah that he was being thrown out of hearth and home. Jinnah was, if anything, secular, with many Hindu friends, but he had little flexibility because there was literally nowhere else in Karachi that the newly formed Foreign Office could be billeted. Rumour has it that Mohatta, incensed at the absence of natural justice in the country, said to Jinnah, "If this is your Pakistan, you can keep it", and left the next day for Bombay. The story may be apocryphal but it strikes a chord.

That Mohatta would have left Karachi with a huge sense of loss is supported by the views expressed by L.K. Advani, one of the founding fathers of the Hindu fundamentalist political party, the BJP, who wrote as recently as 2008 that Karachi was his "favourite city".[9]

The Hindu faith practised by the Sindhi was not the muscular version common in neighbouring Gujarat. The Sindhi version was somewhat syncretic, incorporating Muslim Sufi thought with Sikh strands on a Hindu platform. In fact, till politics intervened, there were regular pilgrimages by Sindhi Hindus to meet their Sufi 'masters' in Pakistan. What this suggests is that it should have been relatively easy for the Sindhi Hindu to find his place in the new dispensation. But this did not happen. Karachi is

Pakistan's most, possibly only, cosmopolitan city. How different would it have been had it retained some elements of its Hindu character post 1948?

This brief monograph is a nod towards correcting a particular lacuna of recent history. It stems from an appreciation of material objects and a desire to understand where they came from and why they are what they are.

NOTES

1 Census of India 1941.

2 Ibid.

3 Boivin, Michel (ed.), *Sindh through History and Representation*, Karachi, 2008.

4 Anand, Subhadra, *National Integration of the Sindhi*, Delhi, 1996.

5 Markovits, Claude, *The Global World of Indian Merchants*, Cambridge, 2000.

6 Khan, Dominique-Sila, chapter on Jhulelal and the identity of Indian Sindhis, in Boivin 2008.

7 Ansari, Sarah, 'Pakistan's 1951 Census: State Building in Post-Partition Sindh', *Journal of South Asian Studies*, vol. 39, no. 4.

8 Census of Pakistan 2023. Provisional figures from the Pakistan Bureau of Statistics. This percentage includes Scheduled Castes (0.99%).

9 L.K. Advani, *My Country, My Life*, Bombay, 2008, and conversation between L.K. Advani and Nasreen Askari, Mohatta Palace Museum, 5 June, 2005. Mr. Advani visited the city of his birth and surveying the city's changing skyline from the rooftop of the Museum said "What have you done to my favourite city?"

TIES THAT BIND

The textile crafts of Sindh are amongst the oldest in South Asia. The topography of the land has led to the emergence of styles of dress and ornamentation that have become markers of identity. The inhabitants of the central plains, Vicholo, have dyeing, printing, weaving and embroidery skills. whilst those who inhabit the plains between the west bank of the Indus and the Kirthar and Lakhi mountains, Katcho, employ finely embroidered geometric patterns with mirrors, *shisho*. The areas to the north, Siro, are known for their festive and intricate silver-thread embroideries. *Dhagay jo bhart* or thread-work embroideries from the semi-desert region of Tharparkar in the south-east are among the most evocative, with stylized motifs of the flowers of the desert, birds and peacocks. The delta, Larh, at Thatta has historically covered the entire gamut of textile traditions, woven, printed, embroidered and quilted.

Rural populations have been content to clothe themselves in readily available materials, often woven on village handlooms and decorated with simple patterns shared across class, colour or creed. Some garments have remained largely unchanged for centuries. The trouser or skirt (*shalwar, suthan, gaghro* or *parho)* and tunic (*kurta, peheran, kurti, choli* or *gaj)* accompanied by a headshawl are popular with women. Subtle regional differences in cut and accessories help to distinguish between groups. The neck opening on the right of a *kurta* points to a Muslim wearer and on the left to a Hindu. Men wear *lungis,* sashes or silk turban-cloths woven with silver- and gold-wrapped thread for ceremonial wear. Traditional costume, accessories and animal adornments decorated by women for their families are still in use among a number of groups throughout the province. Although these textiles may have techniques, design elements and uses in common, many are peculiar to individual communities, distinguishable by their style, motifs and colour.

The distinctive parameters of dress in Sindh have not changed a great deal over time. Embroideries are determined by habitat, climate, tradition and community. Linear forms and elegance alternate with coarse textiles and geometric symbols all along the Indus Valley. Colours add significance and dimension to fabric. Red is the symbol of the sun and the glowing bride who will in due course of time give birth to a new form of light. Saffron or *geyrou* is the colour of reverence and mother earth, while yellow is the colour of spring and blue represents rain-filled clouds, although blue is not commonly used in embroidery. Like the changing shades of the skies and the tempo of life, women absorb these endless movements like the rhythms of music. The patterns and motifs produced are an affirmation of the existence of life.

Given the importance of Sindhi embroidery in the overall canvas of South Asian textiles and its complexity, a brief description of the principal stitches is set out below.

Pakkoh

This is the most common style of decoration employed in folk textiles, in which garments and accessories are embroidered with strong dense stitches in high relief from the ground fabric. Frequently, even after the fabric has worn away, the stitches remain intact; hence the name, *pakkoh,* implying 'fortified' or 'permanent'.

Pakkoh *Kacho soof* *Pakkoh soof* *Hurmitch*

The stitches can be arranged to form motifs – curvilinear, geometric, floral, bird, animal or figurative – which are then absorbed into patterns. The stitches themselves consist of the closely packed buttonhole stitch, also known as the 'Sindhi stitch', supplemented as needed by varying combinations of stitches such as the square chain, the interlacing or *hurmitch*, the satin or the filling stitch with ridged edges, laid and couched. Some examples of *pakkoh* embroidery can be seen in the Collection, nos. 16, 42 and 77.

Patterns are stamped on to cloth using carved wooden blocks or *por* dipped in a paste made from soot, mud or powdered resin dissolved in water. Mirrors may be attached in a tight buttonhole stitch and provide focal points in the overall pattern.

Kacho soof

Kacho soof or *soof* refers to embroidery based on a thread-counting technique in the ground fabric, generally done without any outline or drawing, and is used for geometric motifs. Occasionally, threads may be drawn out to identify areas to be filled in. Fine satin stitches are put in from the reverse, which lie flat and produce geometric or spatial relationships with each other in a horizontal, vertical or diagonal grid on the front of the fabric. When the stitches show on both sides of the cloth, it is called *soof*. If not seen on the reverse, it is called *tanth*. All Meghwar embroiderers practise *tanth* embroidery. By virtue of their geometric forms, *kacho soof* stitches often lend themselves to chevron patterns on the borders of the textiles, and are referred to as *lehr* or waves. Examples of *tanth* embroidery are nos. 4 and 6 in the Collection.

Pakkoh soof

The *pakkoh soof* technique is adopted primarily for a pictorial form of embroidery for objects such as a wedding scarf, *bokano*, no. 67 or a coverlet, *roomal*, no 1. Motifs may include peacocks, sand dunes, scorpions and temples (see, for example, no. 73).

The design is first put on to the cloth with a simple stitch and then filled in with satin stitches by inserting the needle from behind the cloth. Small square compositions with *pakkoh soof* embroidery are also seen on prayer mats used by the Shi'a Hazara group in Afghanistan and Quetta. The *pakkoh soof* style originated with the Sodha Rajputs in the nineteenth century.

Hurmitch

The *hurmitch* or interlacing or darning stitch is found in embroideries from all over Pakistan. It is claimed by some scholars to be of Armenian origin but Sindh claims it as its own.

Its patterns are printed on to cloth using wooden blocks or *por* and stitches are put in to conform to the outlines marked out. *Hurmitch* patterns have a variety of forms, *dublee jo por* or round box pattern, *chaunk jo por* or square pattern, *nangel jo por* or snake pattern, *kot jo por* or fort pattern and *leher jo por* or wave pattern. The Balochi *hurmitch* is particularly fine, often worked in conjunction with a herringbone stitch and silk thread to create a magnificent border pattern.

The Maheri community in north Sindh around Sukkur and further north in Rahim Yar Khan use exceptionally fine *hurmitch* stitches similar to those of the Baloch groups to provide borders

Kanbiro　　　　　　　*Nehran*　　　　　　　*Kharek*　　　　　　　*Gontri*

for panels of embroidery in their dresses. No. 36 is an example of a *roomal* with *hurmitch* borders. The *abochhini* at no. 7 shows the *hurmitch* in different four-square motifs.

Kanbiro

Kanbiro embroidery is normally put on new fabric when layers of cloth are sewn together. Coverlets such as *rallis,* quilted bags and purses, *bujhkis,* highlight its use. There are two basic stitches used for this work, a double running stitch similar to a Holbein stitch and a back stitch. Both stitches may be used in the same piece of work. The bags are immaculately sewn and constructed with a grid pattern in the stitching. Within each grid there is a square (or a diamond) with two lines of white thread circumscribing the square. This makes for a geometric and repetitive appearance.

An example of *kanbiro* embroidery is a dowry bag at no. 79.

Nehran

Nehran is a component stitch in the *pakkoh* style. It is made up of bars of satin stitch, tightly arranged together in V-shapes. The shapes follow the outlines of borders, the edges of embroideries or individual motifs. The stitch is usually in a bright colour which occurs all along the periphery of the V-shapes. As the end result resembles the shape of a human eye, this stitch is called *nehran,* the Kutchi word for eye.

Kharek

This stitch is so called because it resembles the leaves of the date palm, *kharek,* and can be part of the *soof* style of embroidery, being based on a thread-counting technique in the ground fabric. Rows of satin stitches are laid down parallel to one another, creating geometric patterns on the working side of the fabric. These stitches occur in the form of grids. A skilful example of this can be seen in a dowry bag at no. 81.

The grids are often outlined in black double running stitch with fine white highlights akin to dots or *zor.* The spaces created are filled in with different coloured threads in a satin stitch. Mirrors are also added. Motifs are densely embroidered to cover the fabric underneath, giving it an embossed effect.

Gontri

Among other stitches in popular use is the *gontri,* a fine zigzag satin stitch that the Meghwar claim to be part of their repertoire, although it is often not immediately apparent. Examples of the *gontri* stitch are most often seen along the borders of textiles. They require consummate skill in their placement and provide colour and precision to the overall arrangement of the pattern on the textile. The Baloch also lay claim to this stitch. Examples of the *gontri* stitch can be seen at nos. 1 and 78 at the centres of the large squares.

Phulrho *Sheesho* *Resho* *Zanjiro*

Phulrho

Phulrho, a type of *pakkoh* stitch, is a widespread Sindhi stitch with fine ridges along its length. It is used largely for floral motifs, and occurs in profusion in the ceremonial garments of the Lohana group, where tunics or *cholas* have thick encrusted embroideries. Nos. 40 and 56 are examples of *phulrho.*

Sheesho

The *sheesho* or mirror stitch, as its name implies, is used for attaching mirrors to the underlying fabric. Mirror work is widely prevalent in Sindhi and Balochi textiles and accordingly the *sheesho* stitch is common to a large number of groups. There are numerous examples of this stitch throughout this volume.

Resho

The *resho* or couched stitch is used to outline motifs and highlight borders with thread. A number of threads are laid down and attached at intervals to the ground fabric. Another form of couching is the *dand tanko* (i.e. with teeth). The stitch can be gathered or placed flat but it is essentially used to mark the outer extent of the embroidery. For an example, see no. 77.

Zanjiro

A chain stitch normally used to delineate motifs from each other. The central circle of no. 75 is an example of this chain stitch.

Kanjiro

The *kanjiro* is a particular garment embroidered by the Kutchi Meghwar in the *pakkoh* style. It is richly embellished over the bosom and shoulders with special motifs that may include prancing peacocks, dunes, and circular motifs known as *chandro* or moon; it is regarded as an offering for fertility and is especially made as a wedding blouse.

The *kanjiro's* bands and sections have a special terminology and significance. A continuous band around the neck with mirrors linked to each other is called the *rano bandh* and is usually embroidered on the shoulders and chest. A band running along the *rano bandh* (see no. 40) is called the *aanteriyo* and contains a number of motifs, namely *bunti, booti, gul* and *tikko.* Colourful thread, called *val,* is stitched around the *rano bandh.* A *val* features the *bunti* or the *booti,* herbal motifs, and the *gul* or flower, in different colours. *Taunr* is a circle woven on a *kanjiro.* A smaller circle within, of a different colour, is called *maniyo waro taunr.* Patterns around the *val* are called *jaatun.* The *cholo* is a blouse similar to a *kanjiro,* especially embroidered by the Kutchi Meghwar group. A *pothio* is a blouse worn by widows and older women.

1 2 3 4

STITCHES IN TRADITIONAL SINDHI EMBROIDERY

1
a) filling stitch (*kacho*)
b) chain (*zanjiro*)
c) laid and couched (*resho*)
d) interlaced herringbone (*hurmitch*)

2
a) zigzag (*gontri*)
b) filling (*kacho*)
c) laid and couched (*resho*)

3
a) filling with ridged edges (*phulrho*)
b) buttonhole (Sindhi)
c) laid and couched (*resho*)
d) knot (*zeero*)

4
a) filling with ridged edges (*phulrho*)
b) mirror work (*sheesho*)
c) buttonhole (Sindhi)
d) chain (*zanjiro*)
e) laid and couched (*resho*)

PAINTED, PRINTED AND TIE-DYED FABRICS

Block printing uses carved wooden blocks sequentially dipped in dyes and stamped on to cloth. It is done on cotton, silk and a variety of synthetic fabrics; silver and gold printing is a popular substitute for expensive woven brocades.

We have records of a medieval trade in printed cotton textiles from the western coast of India to the Mediterranean along the routes of the Persian Gulf. The mordant-dyed and resist-printed cotton *ajrak* is perhaps the best known of these textiles. The term *ajrak* may have evolved from *azrak,* Arabic for blue. The colours of the traditional *ajrak* are shades of blue and red (historically, indigo and madder being the principal dyes) used in a repertoire of patterns that are floral as well as geometric. *Ajrak* making is a complex process which employs mordants and involves several stages using resist to dye areas of the fabric selectively.

Alongside *ajrak* block printing, carved wooden blocks were also used to hand-print textiles, notably chintz or *cheent*.

Another type of garment often featuring block printing is the *maleer,* commonly used for embroidering shawls.

Oral traditions relate that tie-dyeing, *bandhani*, which relies on a resist dyeing technique, travelled from the eastern areas of Sindh to Kutch and Gujarat. The *bandhani* technique is now more common in Gujarat. *Bandhani,* derived from *bandhana,* to tie, is a well known style of creating patterns on cloth by tying or knotting specific areas to protect them from dye. *Bandhani* patterns vary in intricacy from a single dot to a combination of borders and medallions and are essential dress in many of the desert areas of Sindh and Punjab. *Bandhani* is used widely on silk, cotton and woollen

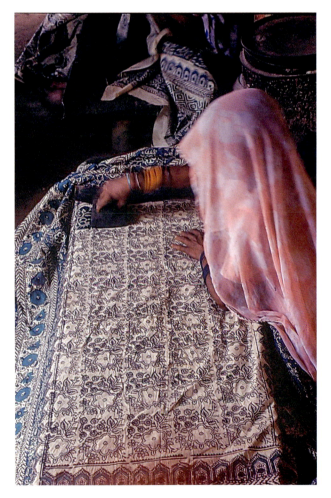

Block printing a spread. Mithi, 2013

32

- Wooden blocks used to print fabric
- Applying resist to the fabric
- Boiling the fabric in an *alizarin* bath
- Washing the fabric

- The tie-dying process begins with dipping the wooden block in dye before printing
- Areas of the pattern are knotted to protect them from the dye
- The knotted fabric is ready for dyeing and will be dipped in dye
- The *bandhani* is ready

fabrics; the patterns on silk are generally very fine, and popular for ceremonial garments. For cotton and wool, the repertoire of designs is restricted and the dots are bolder. Woollen tie-dyed fabric is used for skirts or headshawls by the desert communities of Rabaris.

Woven warps

The term *khes* is used as a specific term for the thick checked cotton fabric of Sindh and Punjab most often used as a spread, a coverlet or as bedding. It continues to be woven in geometric patterns on a pit loom in a twill or double-weave technique. The main field is filled with a small repeating pattern, usually a diamond, a triangle or a polygon enclosed within a square. In Multan and elsewhere in Punjab, the patterns are bolder than the weaves of Sindh. Popular colours are deep yellow, red, blue, black, green and white.

Immersing the fabric in dye, after knotting

THREADS IN TIME

The migration of people across geographies has often obscured the origin of a number of community attributes, embroidery being one. Most of the groups criss-crossing Sindh wore richly decorated garments in everyday life and on festive occasions. Some groups decorated their own dresses whilst others commissioned professional embroiderers. Down the ages, the Meghwars, the Rabaris, the Jats and the Baloch have fascinated ethnographers with their needle work. It is intriguing that, with no direct links, people thousands of miles apart and hundreds of years removed, share significant similarities in dress. This leads one to believe that they may well have been linked, at some point, in time and space.

Jat

The Jats and the Meds were the ancient inhabitants of Sindh. Today, the deltaic areas of the Indus are home to Jat nomads, a pastoral community of Scythian extraction. A number of groups in Badin also continue to breed camel and sheep but most have taken to farming along the border with Tharparkar. The Jats are an impressive and handsome people who travel in tightly knit independent groups led by their leader or *malik*. Today, diverse Jat groups such as the Malkani, Nuhani, Jummani, Faqirani and Umrani continue to breed livestock.

Women's costumes of the different groups have identical elements of design bearing the same name. They are drawn from nature and reflect the transition from a nomadic to an agrarian way of life. Stylized forms of the sun, moon, stars, flowers, streams, rice grains, millet stalks and fields of crops are simplified and repeated to make up ingenious minimalist patterns. Motifs are grid-based, generally of the same size and uniformly balanced. There is extensive use of mirrors and these can vary in size from tiny imperceptible dots to pear-shaped discs.

Women wear a *chori,* a long full skirted dress with a gathered trouser, a *shalwar,* and a large shawl, *odhani.* The *chori* reaches to the ankles and is finely pleated beneath the armholes. The bodice or yoke is usually adorned with an embroidered *gaj.* The form and colour of the *chori* indicates the woman's social status while her regional identity may be conveyed through the distribution of its motifs.

Red *chori*s are worn by young girls, brides and fashionable women while widows and older women wear black *chori*s, with less elaborately embroidered *gaj* and decorated with mirrors. The *gaj,* also referred to as a *giichi,* covers the chest entirely, usually embroidered in the form of a grid with four segments.

The embroidery is concentrated on the yoke of the garment. The layout has multi-coloured divisions like the spokes of a wheel. The coloured wedges on a blouse front (see fig. on p. 37) are seen as symmetrically placed roundels embroidered in laid and couched stitches. The edges of the *gaj,* the sleeves, the hem and the neckline together with its opening are fortified by a striking black cretan stitch, the *gaan.* Intricate work is done with a buttonhole or Sindhi stitch, square chain or *zanjiro,* filling or *kacho,* interlacing or *hurmitch,* ridged or *phulrho* or laid and couched or *resho* stitches. Jat embroidery is deceptive, as at first glance it appears uniform, but has subtle variations according to the *orak* or clan of the wearer.

A Jat woman working in the field. Shah Bandar, Thatta 1996

Circular, radiating motifs on the bosom such as those seen on no. 53 are referred to as *chatil* (from *chati* or chest). The entire embroidery with its wedge shapes symbolizes the sunflower or *suraj mukhi*. The embroidery is framed by rows of stylized flowers in narrow borders or columns. It is less dense than the *pakkoh* style of Tharparkar.

Rabari

Rabari communities, who are closely related to the Jats, pursue a semi-nomadic or pastoral way of life as camel and sheep herders and are found all over the desert and delta of Sindh. It is commonly believed that they migrated from the western areas of Balochistan into Sindh, Rajasthan and Thar a millennium or so ago. They maintain their pastoral life-style, the men moving with their livestock in search of fodder and the women living in small encampments. Although a distinct community, the Rabaris share styles of dress and articles of daily use with Jat groups.

Rabari textiles are amongst the most compelling in Sindh because of their vibrant colours and the bold use of large mirrors attached to the ground fabric. The mirrors vary in shape from spectacular circular discs to large square shapes and triangles juxtaposed with one another. Stitches used include buttonhole, square chain, interlacing and couched. In addition to embroidery, Rabari costumes use shells, buttons, tassels and cords. Rabari women wear a long blouse that covers their bellies, the *kanjiro*, and somber coloured woollen garments in black for everyday wear. Special festive clothing for the young include bright red skirts, *pheliya* or *kanchali*, with dark red *bandhani* shawls. A newly married Rabari

Rabari comrades. Kasbo, Nagarparkar 2003

girl will have a festive red tie-dyed pattern on her headshawl or *abochhini*. Young girls have floral motifs on their garments; the wedding shawl or *chunri* has a *buta* or cluster in a motif of blossoming buds. The *phulrho* pattern of round motifs representing open blossoms is worn by young mothers, as widows do not generally wear mirrors.

The embroidered *abochhini* is worn by both Muslims and Hindu groups, as are the *ajrak* or the *maleer*. Men use theirs as a turban or wrap, women as a head covering or veil. The patterns are block printed in dark blue or indigo on a madder red, with the block making done principally by men.

Hindu pastoral groups on the border with India share social and religious traditions with their clans across the border. They work as professional embroiderers, leather workers, tanners and farmers and often act on commissions from other groups.

Rabari women work in the *pakkoh* style of embroidery, with subtle differences in colour and mirror work as markers of identity. They wear a three-part costume, an open backless blouse, *choli* or *kapadu* which is embroidered, a skirt, *gaghro,* and a veil or head covering, *odhani*. A ceremonial veil or *ludi* makes a distinctive Rabari adornment and is woven by girls for their dowries. It has tie-dyed geometric motifs of temples in orange and yellow with woven borders at the ends. Stylized renditions of the yellow mimosa flower are embroidered in the centre field and along the central seam, as seen in no. 26. The narrow width of the shawl is explained by the narrow loom on which it is generally woven. As with all Rabari motifs, there is little distinction between representation and abstraction.

A newly married Rabari woman will have a red tie-dyed pattern on the *abochhini* or shawl worn over her head. The gathered bodice of a married woman is shorter and tighter and a blouse pleated at the breast indicates that she is married. The embroidery invariably has mirrors, with yellow and white being favoured colours. A widow wears a black *bandhani* and the embroidery is done directly on to the fabric without any tracing. They claim that black is the colour of tradition and in wool!

Rabari men wear a turban, a shoulder cloth and a gathered jacket called *kediyun* similar to the Rajput dress with a loincloth or *dhoti.* Men's shirts occasionally have a fine stitching of motifs that are floral or represent animals, birds, especially peacocks, the tree of life or a half moon. *Bakhia waro bhart* is the name given to the stitching. Stylized serrated motifs are referred to as *dand* or teeth.

Meghwar

The Meghwars are a community of trailblazers, as they are responsible for the evolution of a number of stitches used by the different groups. The Meghwar communities of Thar excel as leather workers and share a number of decorative traditions with the Rabari groups. They are essentially a community of Hindu tanners that were employed as court artisans to the rulers of Kutch.

The term Meghwar is derived from *meh,* cow and *gharendar,* one who tends to buffalos and cleans buffalo hides. Meghwar in Sindh are also known as Manghwar, Menghwal or Megh. They are the principal component of the scheduled castes in Pakistan,[1] with ancient roots in the Indus Valley, most likely pre-Christian or Dravidian in origin. They maintain their original occupations but have declined in the social hierarchy since they lost control of their territories.

The Meghwar embroider garments in the *pakkoh* style employing both geometric and floral motifs in a dense manner that derives its origin from the areas around central Tharparkar. Their apparel is invariably vibrant in dazzling shades of purple, pink, mauve, parrot green, yellow and often, a dark blue. No other community appears to have this range. No. 2 is a coverlet with richly embroidered centre or *dari* and pairs of peacocks surrounding it.

A number of accessories made for a bridegroom include a long narrow scarf or *bokano* which will be draped around his head to hold his turban in place (see nos. 66, 69, 70). A broader version, belonging to the Rajput, Thakur or Meghwar groups, seen at nos. 73 and 74, is a ceremonial *cummerbandh* or *karhbandhro* wound

A Meghwar woman. Khorwah, 2017

around the bridegroom's waist, which may be knotted with the embroidered ends left hanging down.

Flowers symbolizing fertility and prosperity for the bridal couple are found in practically all wedding garments. The largest and most distinctive of these is the Meghwar man's shawl or shoulder cloth, a *maleer,* which can be seen at no. 20, embroidered by the bride and given to the groom to wear as he arrives at her house for the wedding ceremony. The embroidery has been done on a large resist-printed and mordant-dyed textile where the ends have been heavily worked in a *pakkoh* style with the iconography of the desert, dunes, peacocks, butterflies and scorpions subtly concealed among floral blossoms. The peacock is a symbol of fertility and prosperity and the shawl is thrown around a bridegroom's shoulders by his female relatives as he leaves to collect his bride on their wedding day.

A Baloch family, en route to Lahoot Lamakaan,
a place of pilgrimage. Khuzdar, Balochistan 2003

Meghwar women are passionate embroiderers, having adopted influences from both the Rajasthani and the Kutchi traditions. Meghwar needlework represents an ingenious blend of both styles. *Gontri* embroidery is one such example, close to both Afghan and Balochi needlework. Meghwar embroiderers insist that this sophisticated zigzag pattern at the borders of cloths, as seen on nos. 1 and 4, although common in Balochi embroidery, originates with the Meghwars.

Baloch

The Baloch are a distinct ethnic group with a different geographical origin who have migrated over centuries and today have an identifiable presence in Sindh. Sindh was an attractive destination because of its well-ordered status after the British conquest (Balochistan remained feudal) and the increase in agricultural production after the building of canals. Some of the Balochi and Sindhi traditions combined to create a distinct group of their own (such as the Maheri discussed below) and there is a sufficiently large Balochi presence in Sindh to merit a reference to Balochi embroidery here.

The adornment on a Balochi woman's dress or *pashk* is unparalleled as no other group has the same quality and nature of decoration. The garment consists of an ankle length, loose-fitting, long sleeved dress, together with gathered trousers or *shalwar* and a large shawl or *chaddar*. There are usually four panels of embroidery in the *pakkoh* style on the yoke of the garment covering the chest, one on the sleeve cuffs and a long narrow pocket, a *phudo* or *pandohl*, that stretches from the yoke to the hem.

Balochi embroidery, or *doch*, is extraordinary in its repeating composition of pattern and colour. The repertoire of stitches is particularly impressive, with immaculate renditions of satin or *mosum*, interlacing or *chinnuka*, herringbone or *maeen pusht*, chain or *kash*, laid and couched or *bakalo* and square chain stitches. There are minor regional variations in the colour and pattern of the embroidery but the form of the *pashk* is a constant. The panels maybe embroidered directly on the fabric of the *pashk* or on pieces of coarse cotton cloth, *alwan*, which are then stitched on to the *pashk* and may be reused.

The *pashk* of groups in central Balochistan have a repertoire of over fifty richly embroidered patterns using silk floss in a palette of red, orange, yellow, green, white, blue, purple or black. They were

A Baloch woman wearing a *pashk* and a silver torque, *hansli*. Ranikot 2005

traditionally worn with contrasting baggy trousers of striped silk fabric called *kanavez* and large shawls or *chaddar*s with embroidered borders but are now worn with matching *shalwar*s and *chaddar*s.

Other communities

A group that is particularly skilled at fine needlework are the Maheris,[2] who live in the Kirthar mountains. They are concentrated along the border with neighbouring Balochistan, around Sukkur and in the more densely populated central plains. Their embroideries rely on *hurmitch* stitching and fine mirror work. Proficient Maheri work marks a bridge between the Sindhi and Balochi styles of embroidery, as can be seen at nos. 3 and 7.

Further west in the mountainous reaches of the Kirthar range in Thano Bula Khan, the Nanakpanthi Lohanas (devotees of Guru Nanak) wear *cholas*, straight knee-length wedding shirts covered in panels of dense embroidery using double buttonhole, ridged, square chain and open chain stitches. Young girls prepare three such garments for their weddings in red, yellow and green in a pieced construction. The red *chola* is for the wedding night, the yellow is for the henna ceremony and green for her post-nuptial visit to her parents.

In Soomrah embroidery silver- and gold-wrapped thread is twisted and stitched on to fabric using small circular motifs to compose larger ones. This work is called *marorhi*.

There are numerous other tribal communities, both Hindu and Muslim. Hindu groups include the Maheshwaris, Ahirs, Thakurs, Suthars, Dheds, Bheels and Kohlis. Muslim groups include the Soomrahs, Langhas, Halepotas, Noorhias and Khaskhelis.

NOTES

1. This term is not in common use in India though it is still used in Pakistan. The word '*Dalit*' is used instead in India, though its use has been discouraged by the Government of India since 2018.

2. The Maheris are described as a branch of the Kalmati Baloch, who migrated centuries ago from the Kalmat province of Makran and settled along the Hub river and the Maher hills – hence the name Maheri.

THE
COLLECTION

ROOMAL OR POSH

1

Dowry cloth (*posh*)
Suthar or Sodha Rajput groups
Chetiari, early 20th century
Silk floss on handspun cotton

Ceremonial dowry cloths or *posh* are embroidered by the bride to wrap gifts for the bridegroom. They are often executed in the *soof* style of embroidery. Each *posh* has a vividly coloured central square, the *dari* or window. The one seen here contains star shapes or *taro phul,* also referred to as the *chakki* or wheel. Stylized peacocks facing one another around the *dari* are referred to as *dhangan* and symbolize the coming together of the newlyweds, as they sit across from each other for the wedding rituals. The green border with small triangles at the margins of the *posh* is the *kungri* and is outlined by the *lehr* or wave, a particular feature of the *soof* style.

2

Coverlet (*roomal* or *posh*)
Meghwar group
Chachro, Tharparkar, early 20th century
Silk floss on cotton

❧ This *roomal* does not contain a *dhangan* motif, that is a pair of peacocks facing each other, and would have been used during a wedding ceremony only as a wrap for the presentation of bridal gifts.

3

Coverlet (*roomal* or *posh*)
Maheri or Baloch groups
Ubaoro or Rahim Yar Khan, late 19th century
Silk floss on handspun cotton

❧ Finely worked ceremonial coverlets, *roomal*s or *posh*, such as this, have embroidery techniques with strong affinities to those of Baloch groups in the western reaches of Sindh. The exceptionally fine *hurmitch* or interlacing stitch differs from that seen elsewhere in Sindh and marks a bridge between the Sindhi and Balochi styles of embroidery. A central square is surrounded by four smaller squares; brilliant yellow *hurmitch* stitches in zigzag or scalloped bands frame the entire *roomal* and have white *hurmitch* triangular accents on their surfaces.

verso

4

Dowry cloth (*posh*)
Sodha Rajput group
Umarkot, early 20th century
Silk floss on cotton

This dowry cloth has a compelling iconography. Its innermost square, the *dari*, is worked in a fine cross stitch with mirrors, *bachero*. This is surrounded by a second square, the borders of which are framed by *gontri* stitches, an extremely fine zigzag satin stitch of which the Meghwars, who are professional embroiderers, are justly proud, and which is also seen in the colourful embroidery of certain Baloch groups. Following the *gontri*, the field of the *roomal* is profusely filled with mirrors and peacocks seated on leafy stems, along with stylized butterflies, miniature geometric shapes and a repeat of the *gontri* in blue, yellow and gold coloured thread. The outer most border is a traditional repeating pattern of triangles.

5

Coverlet (*posh*)
Maheri group
Babarlo, Sukkur, late 19th century
Silk floss on handspun cotton

 The embroidery on this *roomal* conforms to the style and distribution of motifs generally found on Maheri *roomals*. A wide floral border is conspicuous by the density of its embroidery. The border on the opposite side is narrower and has a geometric pattern. A large central square in the field has smaller squares arranged symmetrically around it. Each of these has eight-sided stars and star eyelets within, leading to a visually pleasing effect.

6

Coverlet (*posh*)

Suthar, Thakur or Meghwar group

Bhalwa, Tharparkar, early 20th century

Silk floss on cotton with mirrors

 This coverlet, originally from the Thar desert, has floral as well as geometric patterns embroidered in the *soof* or drawn thread-style, *chapka*. The large stylized blossoms at the four corners of the central square or *dari* are symbols of fertility. Nine embroidered stars within the *dari* are referred to as the *taro phul*.

As it does not have a peacock amongst its motifs, this coverlet is probably a simple wrap.

ABOCHHINI & ODHANI

7

Woman's shawl (*abochhini*)
Attributed to Mai Rani, Dooloh Faqir Mahar village
Ghotki, Sukkur, mid 19th century
Silk floss on handloom cotton

Embroideries by the Maheri community in northern Sindh around Sukkur use exceptionally fine stitches, particularly the *hurmitch* or interlacing stitch. These embroideries are similar to those of Baloch groups in neighbouring Balochistan. Numerous squares of different sizes are seen within the composition, together with a host of small scatter motifs that represent a crossover style. All the squares enclose floral motifs; the end borders with geometric patterns may be viewed as flowering trees.

8

Skirt (*parho* or *ghagro*)
Syed group
Samaro, Tharparkar, late 19th century
Hand loom cotton with silk floss embroidery

The shades or variation in colour of the floral motifs reflect different stages in the indigo dyeing process of the thread. The embroidery is referred to as *ghungroo-bhart* or bell-shaped embroidery, carried out in a *zanjiro* or chain stitch technique.

9

Skirt (*parho* or *ghagro*)

Soomro or Soomrah group, commissioned from Meghwar women

Diplo, mid 19th century

Indigo dyed cotton embroidered with silk floss

 The *parho* was embroidered by Meghwar weavers with *akhphuli* motifs. The *akhphuli* is a commonly found flowering plant of the desert *(Calotropis procera)*, stylized versions of which are generally embroidered in pink or red floss silk using a ridged or button-hole stitch for the petals, often described as a Sindhi stitch.

10

Woman's shawl (*odhani*)
Syed group
Hala or Mirpukhas, late 19th century
Silk floss on cotton

❧ This characteristic wedding shawl from the central plains uses a fine silk floss for its flowers. The borders contain clusters of flowers or *butas* interspersed with stylized trees.

11

Woman's shawl (*abochhini*)
Memon group
Chelhar or Mithi, late 19th century
Silk floss on cotton

❧ The pattern is known as *panj soof*.

12

Woman's shawl (*odhani*)
Syed group
Umarkot, Tharparkar, mid 19th century
Cotton embroidered with silk floss

❧ The star-shaped central medallion and the half medallions on the upper and lower borders have been put in with a *zanjiro* or chain stitch. The end borders have clusters of blossoms or *butas*, and the field is filled in with small flowers.

13

Woman's shawl (*chadar*)
Sadiqabad
Cholistan, mid 20th century
Tie-dyed cotton

❧ This shawl is from the Cholistan desert of south Punjab, which abuts Sindh. The pattern shows a large radiating sun motif in the centre with yellow and green tie-dyed, *bandhani*, dots that are symmetrically tied. Vegetal forms and stylized bird patterns at the ends, closely related to Rabari motifs are prominent. The patterns vary in intricacy from single dots to a combination of borders and medallions and are essential dress in many of the desert areas of Sindh and Punjab.

<div align="center">

14

Woman's headshawl (*chadar*)

Obtained at the Pir Chanan festival celebrated by both Muslims and Hindus,

Near Bahawalpur, mid 20th century

Printed cotton

</div>

❧ The motifs of the shawl are drawn from the flowers of the Cholistan desert, which is geographically and culturally contiguous with the Thar desert. Bold blooms are highlighted by smaller ones. Cholistan is derived from the Turkic word *chol*, meaning a desert, and like the inhabitants of Thar, the people of Cholistan lead a semi-nomadic life in constant quest of water and fodder.

<div align="center">

15

Bridal headshawl (*chandrokhani*)

Kutchi group

Jamnagar, Saurashtra, early 20th century

Tie-dyed silk and silver-wrapped thread woven at the borders

</div>

❧ A red and black silk ceremonial shawl with a red field has a large central medallion with a number of paisleys on the borders and corners. A scatter of floral motifs, dots and paisleys provide visual interest. The motif at the centre is referred to as the *chandra* or moon – literally a moon-lit textile. The borders that frame the bride's face are embroidered in a *marohrhi* technique, in which gold-wrapped thread is twisted and anchored to the underlying fabric, a style common to Sindh, Gujarat and Kutch.

16

Woman's shawl (*abochhini*)
Lohana group
Sakro, Indus delta, early 19th century
Hand-woven, tie-dyed and embroidered cotton

This ceremonial head shawl has been tie-dyed prior to being embroidered. The pattern has a small diamond at the centre enclosed within a larger square and curvilinear bands or *val* on either side. The squares could represent the cosmos. The bands have embroidered symbols at their ends in the shape of swastikas. Here the swastika is referred to as the *sakhiyo*, an auspicious symbol for the Hindu god Ganesh.

The limbs of the swastika are lined with numerous peacocks, each limb symbolizing fertility, joy and immortality. Mirrors occur within the interstices of the swastika and are referred to as the *rano bandh*, extending to the borders of the shawl above and below. A *hurmitch* or interlacing stitch, in green forms dunes of triangular shape at the borders with rows of peacocks, ensuring that no harm will come to the bride.

<p style="text-align:center">17</p>

Woman's headshawl (*chadar*)

Sammat group

Hala or Nawabshah, late 19th century

Silk floss on hand-woven cotton

Women in the desert communities of Sindh choose to interpret the flowers of the desert as they perceive them. Bridal *odhani*s are a natural expression of their joys and aspirations and with minor variations between communities, follow distinctive arrangements in their motifs and embroidery. End borders on head shawls generally enclose *butas* or oval clusters of flowers in a regular and repeating sequence. The distribution and form of *butas* highlight individual blooms.

<p style="text-align:center">18</p>

Man's wrap (*ajrak*)

Syed group

Matiari, early 20th century

Mordant-dyed and resist-printed cotton

An *ajrak* is a rectangular, block- and resist-printed cotton textile traditionally used by men in Sindh but increasingly also by women. It is often used as a shawl, a turban or a wrap and serves a number of practical functions. Of all the techniques used for the adornment of cloth in Sindh, the *ajrak* is the best known. A laborious process is required for it to be prepared and printed on both sides. The *ajrak*, both as an object as well as its pattern, is emblematic of Sindh. This particular pattern is known as the *kakkar* or cloud.

19

Woman's skirt (*parho* or *ghagro*)
Lohana group, commissioned to Meghwar embroiderers
Mithi, Tharparkar, late 19th century
Resist-printed and embroidered with silk floss and mirrors

The fabric has been resist-printed and embroidered in the *pakkoh* style, in bands. The *pakkoh* style takes its origins from dense, heavily worked embroidery that has historically been linked to the areas around Diplo and Mithi in central Tharparkar. The lowest band with the *rohirho* flower in full bloom is the *chopar bandh*. Above this is the *booti bandh* with flower buds. The uppermost band is the *mooriyo* or peacock *bandh*, with peacocks perched on small trees.

All Meghwar settlements invariably have a cluster of embroiderers within them. The older women insist that a Meghwar girl is born with a needle in her hand!

OVERLEAF

20

Man's wedding shawl (*maleer*)
Lohana group commissioned to Meghwar embroiderers
Diplo, Tharparkar, early 20th century
Hand-woven, mordant-dyed and resist-printed cotton, decorated
with silk embroidery, mirrors, beads and silk tassels

❧ This resist-dyed wedding shawl has the propitious theme of peacocks and butterflies frolicking among plants and flowers. Two lengths are joined by a web, *kheelo,* and are densely embroidered at their ends. The *maleer* is embroidered by the bride and gifted to the bridegroom to wear as he arrives at her house for the wedding rituals. One end is tied to the groom's shawl and the other to the bride's headshawl as the couple leave her parents' house. The richly embroidered squares on the four corners of the *maleer* are each bound by a band called the *aantero,* symbolizing windows of happiness and fertility.

21

Woman's headshawl (*odhani*)
Memon or Syed group
Diplo, Tharparkar, early 20th century
Cotton embroidered with silk

The star-shaped cluster of *butas* in the centre of this *abochhini* depicts, in stylized form, the *akhphuli* flower. Here, the fruit of the plant has ripened and the seeds are in a state of dispersal.

22

Bridal shawl (*odhani*)
Kutchi Memon group
Kutch, late 19th century
Silk thread embroidery on silk

The embroidery on this unusual Kutchi shawl is heavily worked throughout its length and covers its surface almost entirely. The field is filled with peacocks, star-shaped clusters of flowers or *butas* and paisleys on the end borders. There is symmetry in the arrangement of the motifs. The central flower has eight smaller flowers enclosed within it and the embroidery is primarily in a *zanjiro* or chain stitch using an awl or hooked needle used by *mochi* or leather workers.

23

Length of embroidered silk (intended for an *abochhini*)
Lohana group
Sindh, Kutch or Gujarat, early 20th century
Silk embroidery on silk

❧ Flowers using silk thread in a *zanjiro* or chain stitch are placed in rows. The embroidered flowers on this piece of silk are perfectly symmetrical, horizontally as well as vertically.

24

Woman's headshawl (*chadar*)
Possibly Marwari group
Khanpur, Cholistan, mid 20th century
Block- and resist-printed cotton

❧ This shawl has been printed using a resist paste or *roghan* in a decorative style known as *panni* or tinsel work. The *roghan* has been printed on to the fabric using a wooden block to highlight elements of the design. The overall pattern follows a geometric layout, radiating from the centre.

25

Length of printed cotton

Kohli or Meghwar group

Hala or Matiari, early 20th century

Block-printed cotton

❧ The fabric has been block-printed in a paisley or *ambh* pattern.
Lengths of this fabric are generally used for gathered skirts or *parho*.

26

Woman's shawl (*ludi*)
Kutchi Rabari group
Kasbo, Nagarparkar, mid 20th century
Tie-dyed and embroidered goat's wool, felt ball

❧ This is a distinctive Rabari woollen textile, unmistakable in its adornment, woven by girls for their dowries. It has tie-dyed geometric patterns of temples in orange and yellow with supplementary weft borders at the ends. There are stylized medallions in relief of the popular yellow mimosa (*Acacia arabica* or *Vachellia nilotica*) in the central field and along the central seam in *zanjiro,* or square chain and Sindhi or buttonhole stitches. The borders are densely embroidered with mimosa flowers. The narrow width of the shawl is explained by the loom on which it is generally woven. As with all Rabari motifs, there is little distinction between representation and abstraction.

27
Woman's headshawl (*abochhini*)
Sammat group
Dadu, mid 19th century
Silk floss on cotton

❧ Worked in a variation of the *pakkoh* or dense style of embroidery, this delicately embroidered *abochhini* has unspun silk threads worked in long floating stitches on a cotton ground fabric. The central medallion is composed of a number of floral clusters or *bootis* over a field of floral motifs outlined with alternating mirrors, the *rano bandh*. Offset by half medallions at the upper and lower borders and quarter medallions at the corners, the borders on two sides are defined with larger clusters or *butas*. In Mithi, Geeta Bai referred to the blossoms in the borders as the *falsa* or *pharvo* plant *(Grewia asiatica)*.

Above is a detail of a border showing a flower motif or *booti* alternating within stylized trees where blossoms are enclosed within a buttonhole stitch. It is claimed that this signifies a ripe fruit. A repeating feature in such borders is the grouping of five blossoms in a cluster or *butas*.

28
Woman's shawl (*odhani*)
Sammat group
Moro, near Dadu, early 20th century
Silk floss or cotton

❧ The fine silk floss embroidery on this shawl denotes the fruit of the *falsa* or *pharvo* plant *(Grewia asiatica)*. It varies in colour from purple to almost black when ripe. Meghwar women claim that the Sindhi or buttonhole stitch with its radiating threads represents the *falsa* accurately.

29

Woman's ceremonial headshawl (*ludi*)
Rabari group
Near Virawah, Nagarparkar, early 20th century
Cotton embroidered with silk thread

❧ Rabari wedding tradition is embodied in this bridal shawl with its richly embroidered borders of peacocks and floral blooms. The borders and motifs on opposing sides are not identical in their detail. Worked in the *pakkoh* or dense style with accents in *hurmitch* or interlacing stitches, the embroidery is so dense that the fabric below is fully covered in places. Subtle differences in the colours and the mirror work are markers of identity. The stitches used are *zanjiro* or chain, *hurmitch* or interlacing and Sindhi or buttonhole. Younger and newly married girls favour yellow, white and red tie-dyed *ludis*, whereas older women and widows wear sombre colours in black and maroon.

30

Spread (*nath*)
Meghwar group
Hyderabad, early 20th century
Leather-dyed and embroidered

❧ This deer-skin rug, originally in several segments, would have been used as a spread on a camel's back, or as a spread for worship. The leather is dyed white and red at its margins with subsidiary borders in a triangular cutwork design or *kungri*.

31

Blouse or tunic front (*kanjro* or *kanjiro*)

Nohri or Node group

Wangho, Tharparkar, mid 19th century

Silk on cotton

❧ This *gaj* has the characteristic distribution of four squares over the bosom running up to the sides of the neck, the front being embroidered up to the belly. It is representative of Muslim groups who migrated from Sindh to Kutch in the mid eighteenth century and are known as the Node group. The orange band on three sides or *laroon* is often a distinctive feature; it is embroidered separately and then stitched on to supplement the *gaj*.

32

Woman's tunic (*pairhan or kurta*)
Syed group
Hyderabad, early 20th century
Fine cotton with gold-wrapped thread

❧ The neck opening to the right indicates that the wearer belongs to a Muslim group. A fine cotton *kurta* with *chikan kari*, or fine-thread embroidery work, is worn over a petticoat and loose trousers (similar to the tradition in Kutch) known as an *ezar*. The garment has been embellished with *marohri* work, twisted and couched gold-wrapped thread around the neck and along the hem and sleeves.

33
Woman's tunic (*kurta*)
Lohana group
Shikarpur, late 19th century
Gold-wrapped thread on silk

Lohanas are amongst the principal Hindu groups in Sindh. The aristocracy or the affluent class, like the Amils, wore gold- and silver-thread work on silk for ceremonial wear, while the middle classes, such as traders and shopkeepers, wore silk thread worked on silk, generally embroidered by Meghwar artisans. The motif and cut of garments in the northern areas of Sindh often exhibit the influence of Central Asian garments because of close links between the trading centres of Shikarpur and Central Asia.

34

Boy's ceremonial tunic (*kurta*)

Lohana group

Shikarpur, late 19th century

Embroidered silk

This garment was probably made for a special occasion or celebration. It has been embroidered entirely with white silk thread in a *kanbiro* stitch which has both running and back stitches. The neck opening on the left indicates that it belonged to a Hindu or, possibly, a Jain family.

35

Child's wraparound tunic (*angarkho*)
Lohana group
Shikarpur, late 19th century
Embroidered silk

The embroidery on this garment suggests a Lohana background. The fabric is known as *mashru*. It has a silk warp and a cotton weft woven in a warp-faced satin weave. The decorated tunic would have been embroidered for an important social occasion such as a wedding or coming of age in the family. The Lohanas are an affluent trading community found throughout Sindh.

36

Woman's dress or shift (*pashk*)
Khetran or Dombki groups
Probably from Sibi, Balochistan, late 19th century
Silk embroidered with silk thread, woven gold thread, braid and silk

Baloch embroidery or *doch* is outstanding in its intricate stitches. The *pashk* or Baloch woman's dress is an ample garment where the yoke is framed by columns of stitches referred to as *bakalo*. The *pashk* is embroidered in panels, a large yoke covering the chest, a panel covering the sleeve cuffs and a long narrow rectangular pocket, *phudo* or *pandohl*, that runs from the yoke down to the hem. The embroidery is largely in the *pakkoh* style with a repertoire of fine satin, *mosum*, interlacing or *chinnuka* or *hurmitch*, herringbone or *maeen pusht*, chain *kash*, blanket, square chain, cross and couched stitches. The late Nawab Akbar Khan Bugti was of the view that this *pashk* could be of Khetran or Dombki origin.

OVERLEAF

37

Woman's dress or shift (*pashk*)
Baloch group
Probably from Nasirabad or Sibi, Balochistan, late 19th century
Silk embroidered with silk

This unusual *pashk* has been embroidered in a single coloured thread, magenta on a bright yellow silk. The front of the garment is richly embroidered in panels with scattered motifs. The *phudo* or elongated pocket is also densely embroidered and the yoke has embroidered bands from the shoulders to the sleeve cuffs. Elongated medallions along the neck and within the yoke are referred to as the *qila* or fort, a common feature of traditional Baloch embroidery. While the distribution of embroidery on the *pashk* remains more or less constant throughout Balochistan, there are minor regional variations in pattern and colour. The panels may be embroidered directly on the fabric of the *pashk* or on pieces of coarse cotton cloth, *alwan,* which are then stitched on to the *pashk* and can be reused.

38
Woman's blouse front (*paitrho*)
Lohana or Memon group
Tharparkar, late 19th century
Silk floss on silk

❧ This half *gaj* or *adh gaj* has round and almond-shaped mirrors attached in a Sindhi or buttonhole stitch. The floral motifs are all in this stitch with tassels and follow a geometric configuration, spaces being outlined by white stitch over black laid and couched thread.

39

Child's garment (*angarkho*)
Lohana or Memon group
Shikarpur, late 19th century
Silk on thread

❧ This garment has been embroidered in a *zanjiro* or chain stitch using an awl or hooked needle. Decorated on its yoke and along the borders, the embroidery is closely related to *mochi* or traditional leather work.

40

Blouse front (*gaj*)

Lohana or Memon group, commissioned to Meghwar embroiderers

Kutch, early 20th century

Silk on silk, mirrors

❧ The embroiderer has subtly concealed pairs of peacocks within the front and side panels of the *gaj*. The white and orange flowers could be the *rohirho* or the cauliflower, *gobi jo phul*. They have all been embroidered in a *phulrho* or ridged stitch. Circular clusters of flowers, the *rohirho* and the *golharo*, are seen in the upper half of the yoke and have been outlined with the *raja bandh*, the rows of mirrors delineating areas to be filled in with embroidery.

41

Woman's tunic (*cholo*)
Jokhio group
Jherruck or Sujawal, early 20th century
Silk on silk

❧ Some of the embroidery on the chest has been done in a *kharek* or date-palm stitch, in which rows of satin stitch are laid down parallel to one another to form blocks or units. The tunic consists of an elaborately embroidered *gaj* with mirror work and straight sleeves. Bands of coloured cloth are sewn on to the bottom of the *gaj* to facilitate recycling.

OVERLEAF

42

Blouse or tunic front (*gaj* or *kanjiro*)
Lohana group
Badin, early 20th century
Silk on silk

❧ This fully embroidered tunic front would be worn by a married woman. It was probably commissioned to Meghwar embroiderers for ceremonial use. Its size would classify it as a *kanjiro*, a *gaj* that extends below the torso to cover the belly. The *phulrho* or ridged stitch is prominent along with the buttonhole, chain and filling stitches.

43

Blouse (*kanchiri*)
Halepota group
Thario Halepota, late 19th century
Silk on silk

❧ This relatively small blouse front or *kanchiri,* has a band of deep pink flowers with petals embroidered at its lower end. Split stems, *zath*, run down its upper half; the lower band shows deep pink flowers, *phul,* with large petals. The mirror work on the bosom and shoulders has a geometric layout in satin stitch whilst the mirrors are attached in a *zanjiro* or square chain stitch.

44

Woman's blouse front (*gaj*)

Jamali or Dombki group

Dera Jamali, Balochistan, early 20th century

Silk embroidered on silk

❧ This intriguing *gaj* has differing configurations of eight-pointed stars in satin and *resho* or laid and couched stitch.

45

Woman's tunic (*cholo*)

Sammat or Jokhio group

Jati, Sujawal, early 20th century

Silk embroidered with silk, applied mica and silver-wrapped thread

❧ The lower half of the tunic, the *peyti,* with its sparsely embroidered and pieced bands, can be recycled. The cut of the *kurta* – whether from the desert, the delta, the mountains or Vicholo – varies depending on the climate of the area.

46

Embroidered blouse front (*gaj*)
Probably Halepota group
Barh jo Dhoro, Badin, early 20th century
Tie-dyed cotton

Many Halepota embroideries have circular motifs echoing Jat motifs with radiating spokes within them. Ramzan Jat in Badin described the radiating lines as a stylized sun motif and as an important marker of group identity. The stitches invariably include surface darning, satin, Sindhi or buttonhole and *resho* or laid and couched stitches. All these use mirrors as highlights. The configuration adheres strictly to the classical four squares over the bosom, two filled in with large sun motifs and two with eight smaller ones around the neck. Each section of the embroidery is in the *pakkoh* style around the neck, on the shoulders and on the bosom, which has rows of mirrors, the *rano bandh*, to delineate the areas to be embroidered. The mirrors are attached in a Sindhi or buttonhole stitch.

47

Embroidered blouse front (*gaj*)

Sameja or Lohana group

Tando Mohammad Khan, early 20th century

Silk embroidered with silk floss

✣ Cotton faced with silk consists of a layer of hand-woven tie-dyed cloth on which embroidery has been carried out with silk floss. The centres of the flowers are in a *phulrho* or filling stitch with ridged edges. This is characteristic *pakkoh* embroidery, found amongst pastoralist groups, with mirrors set in floral patterns.

48

Blouse front (*gaj*)
Sammat group
Tando Bago, late 19th century
Silver-wrapped thread on silk

❧ This bridal blouse front has been decorated in a precise geometrical layout
with beaten silver strips also referred to as *mukka* work.

49

Blouse front (*gaj*)

Memon or Khatri group

Jati Sujawal, late 19th century

Silver beaten thread, woven silver wire, sequins and tassels

❧ This half blouse front has been richly decorated for a bride with *surma* work, beaten, twisted and couched silver wire, as well as silver sequins and flat coin-shaped ornaments. The work is generally done by professional male embroiderers. This piece appears to be a segment of the garment.

50

Embroidered blouse front (*gaj*)

Meghwar group

Thatta or Diplo, Tharparkar, early 20th century

Silk thread on cotton

The circular motifs on this half blouse front or *adh gaj* are invariably seen on garments from Meghwar communities who are spread all over Sindh. The Meghwar claim that the motifs and radiating lines represent the sun. The stitches include satin, Sindhi or buttonhole, *resho* or laid and couched with mirrors as highlights. The configuration of the embroidery adheres to circles continuing over the bosom, down to the belly. The mirrors are attached in a Sindhi or buttonhole stitch while the small flowers on the borders of the sleeves and below the neck line make up the *nali* or delicate floral work.

51

Detail of an embroidered tunic (*kurta*)

Soomrah group

Sujawal, mid 20th century

Silver- and gold-wrapped thread on silk

❧ Gold and silver-wrapped thread has been couched on to silk fabric and highlighted with sequins. The pattern of the motif has been modeled on a traditional wooden block or *por* described as the *chambo* or moon. Such embroideries are still being made. This work is often referred to as *marorhi*, in which gold-wrapped thread is twisted and anchored to the ground fabric.

OVERLEAF

52

Embroidered blouse front (*gaj*)

Halepota group

Indus delta, early 20th century

Silk on cotton

❧ The embroidery is usually on hand-woven red cloth, the *alwan,* in the *kharek* or date-palm stitch, where parallel bars of satin stitch divide the embroidery into four squares. Star-shaped eyelets occur in bands. Dost Ali Halepota, whom I met in Tharparkar, referred to the star eyelets as grass seedlings.

53

Woman's blouse front (*gaj*)

Lanjha or Jat group

Sujawal or Jati, early 20th century

Silk embroidery on silk

❧ The *gaj* is unusual as it has both circular and geometric forms within it that is often referred to as *chapka* work. The circular motifs with radiating segments reflect Jat influence.

<div align="center">

54

Embroidered tunic front (*gaj*)

Probably Meghwar group

Tharparkar, c. 1950

Silk floss on cotton

</div>

❧ The layout of this tunic front with its distribution of multiple columns is generally uniform, as in most Meghwar tunic fronts. They have circular motifs on the bosom with typical representations of desert flowers: the orange *rohirho*, the white *golharo* and the purple-tinged *akkphuli*. The bands linking the mirror work to the main field are referred to as *rano bandh*. *Gaj* such as these are traditionally fastened at the back with strings.

55

Embroidered blouse front (*gaj*)

Lohana group

Diplo, Tharparkar, c. 1930

Silk floss on silk

❧ This piece has been embroidered in a *zanjiro* or chain stitch and *kacho* or filling stitch. The iconography of the desert is ever present, with scorpions, peacocks, birds and floral blooms.

56

Woman's tunic (*chola* or *cholo*)
Nanakpanthi Lohana group
Thano Bula Khan, Jamshoro, early 20th century
Cotton and silk embroidered with silk

⚘ These *chola*s are straight knee-length wedding shirts encrusted with panels of dense embroidery using Sindhi or double buttonhole, square chain and *zanjiro* or chain stitches. Young girls prepare three such garments for their wedding in yellow, red and green. The yellow is worn for the henna ceremony, red for the wedding night and green when she visits her parents after the wedding. The *chola* is then worn on ceremonial occasions. This was narrated to me in Thano Bula Khan by Masi Basanti. *Chola*s from the west of Sindh, the areas around Thano Bula Khan, Thano Ahmed Khan, Sarin, Mol and Jhimpir have openings at the back when brides first wear them and these are later rotated to the front of the *chola* to facilitate feeding.

OVERLEAF

57

Bride's blouse front (*gunchi*)
Thakur group
Kasbo village, Nagarparkar, mid 20th century
Silk on cotton

⚘ This short-sleeved blouse is elaborately embroidered in the *pakkoh* style with flowers of the desert, mirror work and tassels. I was informed by Gia Bai at Pharwani village that tassels invariably indicate bridal wear.

58

Embroidered blouse front (*gaj*)
Rabari group
Virawah, Nagarparkar, mid 19th century
Silk floss on hand woven cotton

⚘ This rare and classical Rabari *gaj* has been embroidered on madder red cotton. Most of the mirrors are almond shaped and the trefoils on them are described as *mor pagla* as these are talismanic footprints of the peacock intended to bring prosperity, colour and grace to the bride.

59
Embroidered blouse front (*gaj*)
Lohana group
Nindo Shehr, Badin, early 20th century
Silk floss on silk attached to tie-dyed cotton

❧ A central band runs down from the neck and encloses floral motifs. Amongst the mirrors distributed on the *gaj* in a linear arrangement, there are specks or knots that symbolize grain. Such specks are also seen in Meghwar embroideries and are referred to as *churri* or grain. They are in fact meant to provide accents for the mirrors.

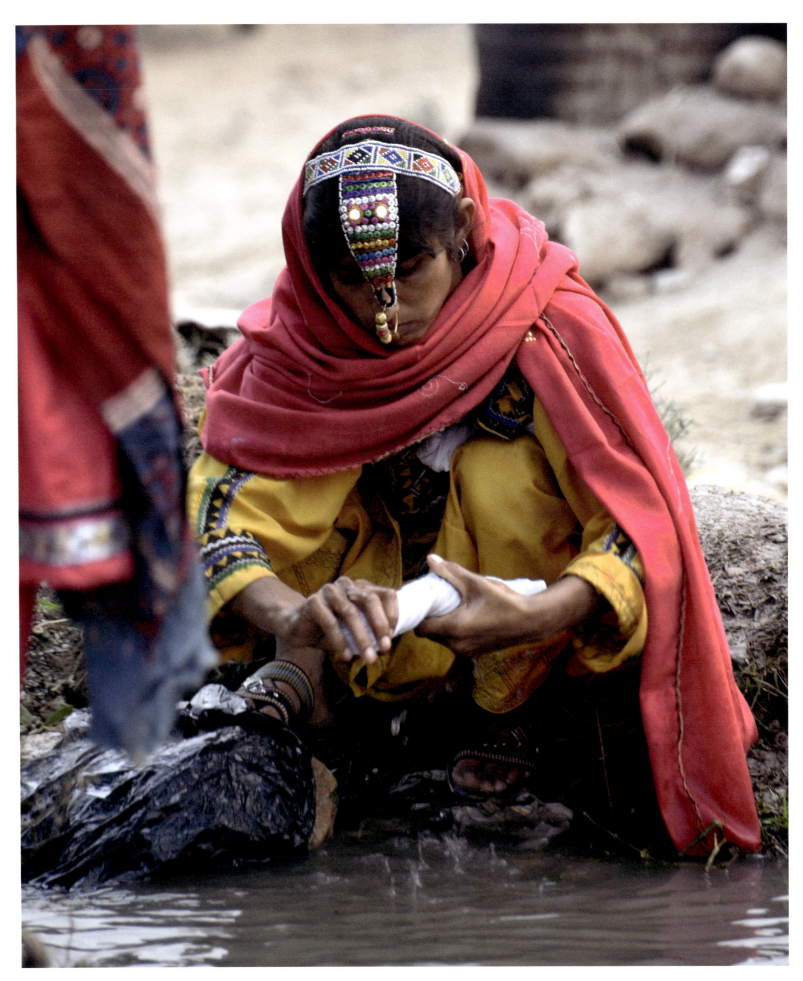

A Khosa woman at the festival of Pir Gaji Shah, Johi, 2018

ADORNMENTS

60

Bridegroom's veil (*morh*)

Halepota or Junejo group

Chelhar, Nagarparkar, early 20th century

Silk floss on cotton, dangles with silk floss, shells, beads, tassels and metal spangles

❧ The bridegroom's face is covered with a *morh* a few days before the wedding and it is taken off after the wedding ceremonies. The embroidered motifs on the veil covering the forehead vary from group to group and derive their name from the technique by which they are attached to the veil. Traditionally, these have shells or *taunr* attached to them as well.

61

Adornment for the bride (*akheo*)
Bheel group
Shaikh Bhirkiyo, Tando Muhammad Khan, mid 20th century
Silk embroidery on cotton, mirrors, glass beads, tassels and reeds

The newly wed bride or *laadi* wears reeds and tassels during a procession on her departure from her parents' house. The circular embroidered motifs on the forehead are the *kungri bandh*.

62

Waist band or belt (*agath*)
Jatoi group
Nawabshah, early 20th century
Cotton with silk thread, silver-wrapped thread, beads and metal spangles

This belt is used to fasten gathered trousers or *shalwar* around the waist. There are a variety of waistbands in use; some are woven in a tablet technique with decorated ends.

63

A dice game (*chaupar*)

Common to many groups

Mithi, mid 20th century

Silk on cotton, mirrors and tassels

This *chaupar* has the flowers of the desert as counters. It is popular all over Sindh and is generally played with dice.

64

Prayer mat (*jainamaz*)

Syed group

Bulrhi Shah Karim, Sujawal, early 20th century

Cotton on cotton, felt balls and tassels

The quilted prayer mat with its characteristic patterns in back stitch has coloured bands of fabric around its periphery, highlighting the panel for the head or the *mihraab*.

65

Coin purse (*nohro*)
Meghwar group
Rohirho village, near Mithi, early 20th century
Cotton embroidered with silk, mirrors and tassels

❧ This coin purse has been embroidered with a number of stitches from the traditional Sindhi repertoire of embroidery: a *kacho* or filling stitch, satin stitch, Sindhi or buttonhole stitch as well as *resho* or laid and couched stitches. The purse is generally wrapped around the waist and tied with a plaited string.

66–68

Bridegroom's scarves (*bokano*)
Probably Suter group
Pangrio, Indus delta, early 20th century
Silk on cotton

Probably Suter group
Pangrio, Indus delta, early 20th century
Silk on cotton

Probably Suter group
Pangrio, Indus delta, early 20th century
Silk on cotton

❧ These long narrow sashes or scarves, *bokanos*, are intended for a bridegroom's attire on his wedding day. They are a gift from the bride's family, and are used to hold his turban in place. As the scarf covers his ears, the term for it is derived from *bo*, meaning two, and *kani*, meaning ears. The scarves have been worked in the *soof* or thread-counting style of embroidery; each object reflects the iconography of the desert – peacocks amongst stylized plants and dunes. The birds are depicted alone or in pairs facing outwards whilst perched on the summit of dunes. Unlike those in ceremonial coverlets, the peacocks in these scarves are not facing each other.

69

Man's scarf (*bokano*)
Meghwar group
Vangho, Tharparkar, early 20th century
Silk on cotton

🌿 The central panel in each portion has two equal panels on either side joined together with a network of stitches, *kheelo*. This sash is in the densely worked *pakkoh* style of embroidery, where the stitches are in high relief on the fabric. The peacocks, talismanic in origin, are seen resting on top of stems and flowers. The flowers are renditions of the *rohirho* and *golharo*.

70

Wedding scarf (*bokano*)
Meghwar group
Chachro, Tharparkar, mid 20th century
Silk floss on silk

🌿 The *pakkoh* style of embroidery has an unusual *hurmitch* or interlacing stitch, in addition to the *phulrho* or filling stitch. Other stitches include the *kacho* with ridged unusual edges, a Sindhi or buttonhole and satin stitches with mirrors.

71

Wedding scarf (*bokano*)
Numerous Bheel groups
Badin, early 20th century
Cotton embroidered with silk and applied mirrors

🌿 This *bokano* is made of cotton embroidered with silk and applied mirrors. It depicts finely embroidered thorns on the field, a common Bheel motif.

72

Man's ceremonial sash (*karhbandhro*)
Suter group
Mithi or Chelhar, early 20th century
Silk floss on cotton with mirrors, beads and tassels

🌿 This is an essential wedding accessory for the bridegroom's waist The *karhbandhro* is embroidered in the *soof* style and, as in a number of wedding garments from the desert, peacocks, sand dunes and triangular representations of fortresses or *kot* are seen.

73

Man's ceremonial sash (*karhbandhro*)

Thakur group

Tigusar, Tharparkar, early 20th century

Cotton embroidered with silk and applied mirrors

74

Man's ceremonial sash (*karhbandhro*)

Meghwar group

Jehpoyo, Tharparkar, early 20th century

Silk floss on cotton and mirrors

❧ This sash has been embroidered in the *pakkoh* style. The imagery of the desert is ever present with peacock atop hillocks of vibrant flowers.

BUJHKI

75
Dowry bag (*bujhki*)
Lohana or Memon group
Dano Dandhal, near Virawah, early 20th century
Cotton faced with silk (which has worn away), silk floss on cotton with tassels

A *bujhki* is an embroidered piece of square fabric, three corners of which are folded over and sewn together to make an envelope shape. *Bujhki*s are used to carry valuables, ceremonial gifts and devotional objects. The central portion of this bag has three bands or mirrors of varying sizes and shapes. Mirrors at the periphery have split stems with *resho*, laid and couched stitches forming two outlines with oval-shaped mirrors in the centre. These have split-stem motifs in a Sindhi or buttonhole stitch. The field has richly embroidered orange and white flowers of the desert. Peacocks on plants guard the four sides.

76

Dowry bag (*bujhki*)
Meghwar group
Umarkot, Tharparkar, early 20th century
Silk floss on cotton, tassels and metal spangles

❧ In this piece, a big square encloses four smaller squares containing sets of motifs. The small central square around which the pattern is based is referred to as the *chaupar*, or 'four sides'. The pinched or scalloped margins of the four principal squares are referred to as *ghungroo*, or bells, each bound within a row of mirrors. The four-petalled flower *darough waro gul* is seen in two of the larger squares and has been put in using a classical Sindhi or buttonhole stitch.

77

Dowry bag (*bujhki*)
Meghwar group
Jamesabad, Mirpurkhas, early 20th century
Cotton embroidered with silk and mirror work.

❧ This beautiful *bujhki* has all the classic hallmarks of the Meghwar group. It has not been used, therefore the colours are vivid. The stitches include the repertoire of the *kacho* or filling, *phulrho* or ridged edges, Sindhi or buttonhole, *zanjiro* or chain and *resho* or laid and couched stitches.

78

Dowry bag (*bujhki*)
Meghwar group
Hinji, Tharparkar, early to mid 20th century
Silk floss on cotton, mirrors, sequins and tassels

❧ The zigzag motif on this bag has strong affinities with Baloch embroidery but Meghwar artisans from Hinji in Thar assert that this is *gontri* embroidery or *bhart* and belongs to them. The patterns produced are invariably geometric and in the *pakkoh* style. Satin, *kacho* or filling, Sindhi or buttonhole, *resho* or laid and couched stitches can be seen.

79

Dowry bag (*bujhki*)
Nomadic groups, *jogis*
Tharparkar, early 20th century
Embroidered cotton

❧ This *bujhki* is immaculately sewn and constructed. It would have been used by wandering minstrels and bards for carrying items of daily use. The stitching is extremely fine and unusual with two basic stitches used for what is generally described as black work, a double-running or Holbein stitch and a backstitch. Tiny squares are worked over two threads. Qurban Faqir, a Sufi maestro who performed at the shrine of Shah Abdul Latif in Bhit Shah, was generous enough to gift me this bag in 1974.

80

Dowry bag (*pothu*)

Rajput or Thakur group, commissioned to Meghwar embroiderers

Umarkot, early 20th century

Embroidered cotton

❧ Known as a *pothu*, this type of bag is carried by the bridegroom, who distributes its contents to the assembled guests. Offerings might include betel nut shavings, fennel seeds, cardamom and cloves amongst others. Embroidered in the *soof* style, a pair of peacocks face each other on top of a tall temple with several decorative lozenges scattered in the field. The border has the classical *hurmitch* or interlacing stitch with alternating mirrors.

81

Dowry bag (*bujhki*)

Sameja group

Sujawal or Thatta, mid 20th century

Cotton embroidered with silk, shells and braid

❧ The embroidery on this bag occurs in squares and circles in a particular stitch known as the *kharek* or date-palm stitch. Within the geometrical shapes there are parallel rows of satin stitches that are laid down in symmetrical groups. This piece has an immaculately woven ribbon to tie around it.

A musician holding a *yaktaro* at a festival. Bhit Shah, 2017

TOPI

82

Cap (*topi*)

Meghwar group

Nabisar, Umarkot, late 19th century

Silk floss on silk

The traditional *topi* is a cap usually worn under a turban to hold it in place. It has a flat crown and a soft spherical body frequently worn with a dome shaped cut-out over the forehead. It is embroidered with cotton and fine silk thread incorporating mirrors. The traditional Bugti or Baloch *topi* has deeper sides and is more intricately embroidered. The Hindu *topi* with large mirrors does not have a cut-out and is generally worn without a turban. The mirrors at the top of this cap are enclosed within split-stem motifs with laid and couched stitches at the top of the crown along its periphery.

83

Cap (*topi*)
Bugti group
Dera Bugti, early 20th century
Cotton embroidery on cotton

❧ A number of stitches, *zanjiro* or chain, *hurmitch* or interlacing, *kacho* or filling and *resho* or laid and couched are visible here. The deep sides of the cap provide a base for the traditional and voluminous Baloch turban.

84

Cap (*topi*)
Baloch group
Jacobabad or Nasirabad, early 20th century
Silk floss on cotton with mirrors

❧ The embroidery is divided into segments of differing sizes. It has a *mehrab* or cut-out at the front. Along with the size of the segment the mirrors vary in size as well.

85

Cap (*topi*)
Lohana group
Thano Bula Khan, mid 20th century
Gold-wrapped thread and silk

❧ This is an example of an embroidered silk cap with gold wrapped thread primarily worn by Hindu groups but without the characteristic mirror work.

86

Cap (*topi*)
Nanakpanthi group
Thano Bula Khan, late 19th century
Silk thread on silk

❧ This rare cap illustrates the prolific use of traditional *kacho* or filling, *zeero* or knotted and Sindhi buttonhole stitches. The work is akin to that seen on women's encrusted tunics of the Nanakpanthi group.

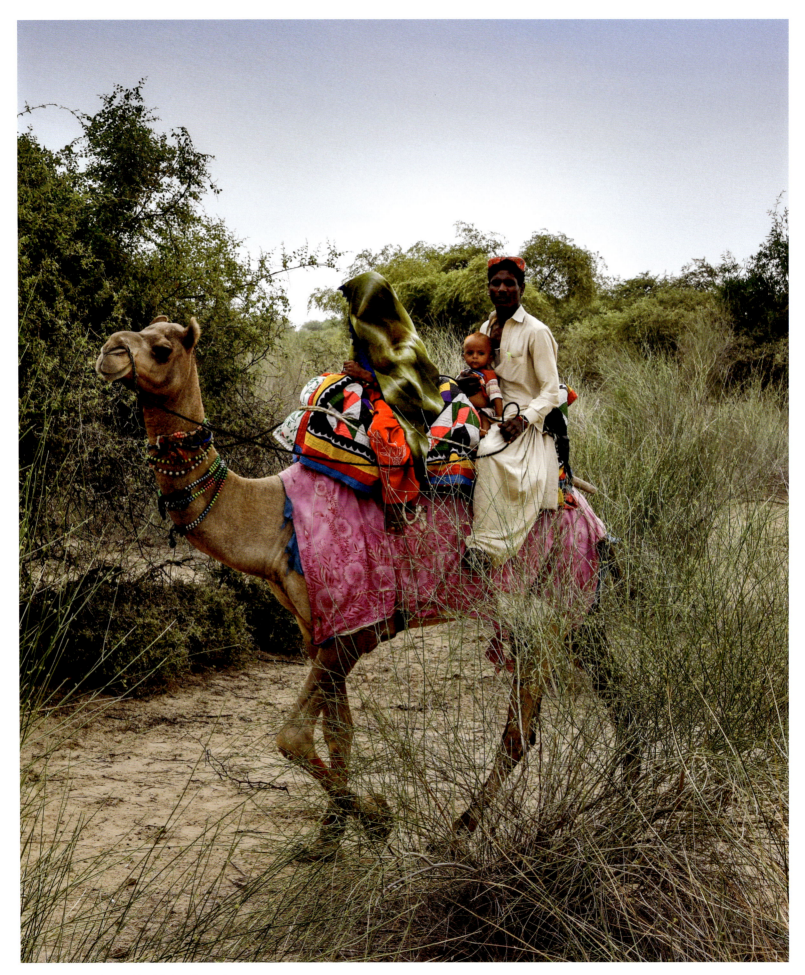

Ship of the desert. Marvi jo Tarr, Bhalwa, Tharparkar, 2007

ANIMAL ADORNMENTS

Pastoral and rural communities who live in a natural environment are known for their passion in decorating their houses and adorning their animals. Festivals, fairs and social occasions provide them with an opportunity to embellish their animals with pride of ownership and receive accolades from the group at large.

CAMEL

87

Adornment for a camel's neck (*gaani*)
Meghwar group
Khipro, mid 20th century
Cotton embroidered with silk floss

88

Adornment for a camel's knees (*godiyoon*)
Maheri group
Babarloun, Khairpur, mid 20th century
Mirror work with beaten silver-wrapped thread,
tassels, mirrors and beads

89

Camel trapping (*tang*)
Rajput group
Sanghar, mid 20th century
Wool and cotton

A girth of this kind is made from goat, sheep or camel hair. The *tang* is normally combined with the *gaani* (placed around the camel's neck), to keep the saddle in place, and with the *godiyoon* fastened around the knees. The *tang* is an impressive adornment: woven in the split ply weaving technique, it has both figurative and geometric patterns, its ends being tastefully decorated with woollen meshwork. Pompoms hang down on the sides of the camel's body and move with its gait.

90

Adornment for a camel's neck (*gaani*)
Embroidered by Meghwar artisans
Nagarparkar, early 20th century
Silk thread, tassels and beads

91

Adornment for a camel's neck (*gaani*)
Maheri group
Mirpurkhas, mid 20th century
Cotton embroidered with silk floss and tassels

92

Adornment for a camel (*agooth*)
Rabari group
Babarlo, Khairpur, mid 20th century
Silk floss on silk, silver- and gold-wrapped thread,
beads, mirrors, buttons and tassels

93

Adornment for a camel's knees (*godiyoon*)
Maheri group
Sujawal, mid 20th century
Silk floss on cotton, tassels, mirrors and metal spangles

94

Adornment for a camel's back and face (*gaani*)
Probably Rabari group
Nagarparkar, mid to late 20th century
Camel wool with buttons and pompoms

95

Adornment for a camel's neck (*gaani*)
Meghwar group
Islamkot, mid to late 20th century
Silk floss on cotton, tassels and mirrors

HORSE

96

Horse adornment (*maki hanno*)
Meghwar group
Islamkot, early 20th century
Cotton embroidered with silk

The horse is a prized possession for its owner. Its pedigree and its training more so. It has adornments for its head, eyes, nose, saddle or *hanno* and its tail. The *maki* is placed on the horse's forehead.

97

Horse trapping (*aandheri*)
Probably Halepota group
Sanghar, early 20th century
Silk floss on cotton, beads and tassels

❧ This kite-shaped trapping is fastened over the head of the horse and has apertures for the eyes. Similar *aandheri*s are also used for bullocks.

98

Horse trapping (*aandheri*)
Thakur group
Khipro, mid 20th century
Silk floss on cotton, beads, tassels and metal spangles

143

99

Horse trapping (*domchi*)
Noorhia group
Indus delta, mid 20th century
Silk floss on cotton, beads and tassels

100

Horse trapping (*aandheri*)
Sodha Rajput group
Indus delta or Tharparkar, mid 20th century
Silk floss on cotton, beads, tassels, mirros and buttons

This embroidery has a profusion of stitches. It has been decorated in the *kharek* stitch in addition to the filling or *kacho*, filling with ridged edges or *phulrho*, laid and couched or *resho* stitches and mirrors. The bigger apertures are for the eyes and the smaller ones for the ears.

101

Horse adornment (*dumchi*)
Maheri group
Ghotki, early 20th century
Cotton embroidered with silk

102

Horse trapping (*dumchi*)
Sodha Rajput group
Sanghar, early 20th century
Cotton embroidered with silk and tassels

103

Bullock adornment (*akkheun*)
Halepota group, commissioned to Meghwar embroiderers
Hala, early 20th century
Silk floss on cotton

❧ Bullocks are adorned for different occasions that may include weddings, festivals or animal fairs. This adornment is placed on the bullock's forehead and eyes. Satin, *phulrho* or ridged and Sindhi or buttonhole stitches are used as well as *resho* or laid and couched stitches in addition to square chain.

104

Camel saddle cloth (*jhul*)
Maheri group
Ghotki, mid 19th century
Cotton embroidered with silk floss

❧ This *jhul* is a rare example in which the border panels imbue the textile with the appearance of a starry night. The central field has remarkably fine *hurmitch* or interlacing, satin, Sindhi or buttonhole and *zanjiro* or chain stitches.

WOVEN TEXTILES
LUNGI, KHES AND LOEE

A *lungi* or wrap serves as a symbol of authority and leadership in a group or community. For a Baloch or a Sindhi, a *lungi* is the highest accolade. A *lungi* is a silk sash worn as a shoulder wrap, a *cummerbandh* or as a turban by men in Sindh and Balochistan. It was popular during the Talpur era (1783–1843 CE) in Sindh as well as in Balochistan, where the *lungi* is usually woven using silk and gold thread, with bands on the borders.

Early travellers in Sindh all commented on the sumptuous turbans, scarves and sashes at the Talpur court. A number of weaves acquired evocative names because of the artistry of their weaves, such as *dilpasand* or 'heart's desire' and *lehrdar* or waves. Many *lungis* were of extremely high quality in terms of both material and weave. From at least the mid nineteenth century, silk was being spun and dyed in Shikarpur before being sent to Sehwan and Thatta to be woven. *Lungis* were also being woven in Sukkur, Rohri, Khairpur, Thatta, Nasarpur and Hyderabad using natural dyes like indigo, madder, saffron, safflower and cochineal.

105
Detail of a sash or turban cloth (*lungi*)
Nasarpur, early 19th century
Coloured silk

106
Sash or turban cloth (*lungi*)
Nasarpur or Thatta, mid to late 19th century
Silk and gold-wrapped thread

107

Sash or turban cloth (*lungi*)

Baloch group

Thatta, late 19th century

Multicoloured silk thread woven with gold-wrapped thread, silk tassels and braid

108

Sash or turban cloth (*lungi*)
Baloch group
Kalat, late 19th century
Multi-coloured silk thread woven with gold-wrapped thread

109

Sash or turban cloth (*lungi*)

Nasarpur, early 20th century

Multi-coloured silk thread

110

Sash or turban cloth (*lungi*)

Syed group

Thatta, early 20th century

Silk and gold thread

The pattern of this *lungi* was referred to as *gulbadan*.

111

Sash or turban cloth (*lungi*)

Syed group

Thatta, late 19th century

Multi-coloured and silver-wrapped thread

112

Woollen shawl (*loee* or *khatho*)
Rabari group
Mithi, Tharparkar, late 19th century
Dyed and undyed wool

✤ While woollen cloth continues to be woven by hand loom in Tharparkar, cheaper Rajasthani pieces are being woven on power looms to cater to commercial demand. They are traditionally white, brown or black, with red highlights in the borders, and woven from dyed as well as undyed wool.

113

Detail of spread (*khes*)
Nasarpur, late 19th century
Cotton

✤ Spreads or *khes* are woven in pairs with a traditional geometric pattern on a pit loom. They use a twill or double weave technique where the main field is filled with a repeating pattern, usually a diamond, a triangle or a polygon. The end borders generally have broader stripes.

114

Spread (*khes*)

Nasarpur, late 19th century

Cotton

❧ The most popular colours for *khes* from Nasarpur are deep yellow, blue and green. *Khes* are generally woven in sets of two pairs, each weave differing in its pattern; well-known patterns are the *pabaro* or lotus, *bili buto* or cat's face, *tiky gul* or dot and flower, *kuto payr* or dog's paw and *panj gulo* or five-flower pattern.

115

Spread (*khes*)

Commissioned by the Talpur families

Khairpur, late 18th century

Silk

❧ This spread was commissioned by the Talpurs in Khairpur, who employed master weavers. This spread is popularly known as *dilpasand* or 'heart's desire' for its pattern.

116

Spread (*khes*)
Lanjha group
Probably Multan, early 20th century
Cotton

117

Spread (*khes*)
Nasarpur, late 19th century
Cotton and silk

❧ A similar *khes* was mentioned by Forbes Watson in his compendium *Textile Manufacturers of India* (London, 1867). Forbes Watson's findings were the first systematic attempt to document textiles being produced in the subcontinent.

118

Woven blanket (*khatho*)
Commissioned by Thakur group
Tharparkar or Rajasthan, 20th century
Sheep's wool

❧ This shawl has been woven on a pit loom with linear geometric patterns.

RALLI

A *ralli* is a patchwork made up of pieces of cloth. The making of a *ralli* is a community activity, where a family and their friends sit together to stitch a spread composed of pieces of cloth cut into squares and triangles of various colours to create a decorative pattern. The two most common techniques are *tukwari*, where pieces of fabrics of varying colours are attached edge to edge to create a pattern, and *chutkinwari*, where coloured pieces of cloth are folded and cut in the style of stencils. These are then stitched on to a ground fabric. The decorative upper layer is called *mathay jo por*, while the lower layer, the *heth jo por,* generally consists of a monochrome fabric or an old *ajrak*. In between these layers of cloth, cotton wool might be added to create a quilt, with a simple running stitch or *kunh* anchoring the layers together. *Rallis* often have dramatic chequerboard designs of geometric cutouts or floral appliques, called *chaugulo* (four flowers), *athgulo* (eight flowers) and *naugulo* (nine flowers). These are often framed by bands of appliqué.

In Tharparkar and in Badin, *ralli*s are also made with a *kanbiri* or back stitch.

119

Spread (*ralli*)

Baito or Mehar group

Pangrio or Indus delta, mid 20th century

Cotton

The central field of this *ralli* has a well-balanced layout in the patchwork or *tukwari* technique. It is bordered by a finely cut band of appliqué and finally a band of alternating square motifs.

120

Spread (*ralli*)
Matiari, early 20th century
Cotton

❧ This quilted *ralli* has a compelling geometric pattern. Mirrors have been sewn on to the squares in the central field. Two borders echo the triangular shapes contained in the centre, and two additional borders, one with mirrors and the other with diamond shapes, add a degree of contrast.

121

Spread (*ralli*)

Tando Allahyar, mid 20th century

Cotton

❧ This *ralli* has been made predominantly in the *chutkinwari* or appliqué technique,
in which the fabric has been cut and shaped before being applied to the ground fabric.

122

Spread (*ralli*)

Meghwar group

Thabo village, Islamkot, early 20th century

Cotton with felt pompoms

❧ This typical Meghwar *ralli* is a combination of both patchwork and appliqué techniques
on the borders as well as the field. The patterns are bold, with cut-work or *chutkinwari* within
geometric squares. The pompoms indicate that the quilt is ceremonial.

aandheri
adornment for a horse's face

aantero or *aanteriyo*
embroidered squares on the corners of a bridegroom's shawl

abochhini
a married woman's shawl

adh phul
a half flower motif

agath
drawstring for a trouser (*shalwar*)

agooth
adornment for a camel's neck

ajrak
traditional resist-printed and mordant-dyed cotton shawl for both men and women

akhphuli
(*Calotropis procera*) a purple flowering plant found in desert areas and embroidered on women's shawls

akheo
adornment for a bride

alwan
cotton cloth on which embroidery is carried out

ambh
paisley motif

angarkho or *angarkha*
a wrap-around garment

bachero
a fine cross-stitch

bakalo
variant of a couched stitch (Baloch)

Bakhia waro bhart
fine decorative stitching on men's shirts (Rabari)

bandhana
to tie

bandhani
tied and dyed

bhart
embroidery

bili buto
cat motif

bokano or *bokani*
scarf made up of two symmetrically embroidered halves of cloth, to hold a bridegroom's turban in place

booti bandh
a band of embroidery with flowering buds

booto, bunti or *buta*
motif of a flower or a cluster of flowers

bujhki
envelope-shaped bag for carrying valuables

buti wari val
flowers on a vine

chadar or *chaddar*
woman's head-covering or shawl

chakki
wheel-shaped motif, also mill for spinning or weaving

chambo
'moon' block

chandra / chandro
moon shape

chandrokhani
bridal head shawl with a moon motif

chapka
embroidery with both floral and geometric patterns in it

chatil
embroidery of spherical shape on the bosom

chaupar
dice game

cheent
printed cotton

chikan kari
thread embroidery on fine cloth

chol
desert

chola or *cholo*
straight, full-length embroidered tunic

choli or *kapadu*
short blouse worn over a skirt

chopar bandh
lowest band of embroidery on a skirt

chori
long full-skirted dress worn by Jat women

chunri
tied and dyed woman's shawl

churri
grain

chutkinwari
piece work for a quilt (*ralli*)

cummerbandh
sash

dand tanko
tooth-like stitch

dari
central square on a ceremonial dowry cloth

darough waro gul
four-petalled flower

dhagay jo bhart
fine embroidery

dhangan
motif of a pair of peacocks facing each other on a ceremonial coverlet

dhoti
loincloth

dilpasand
'heart's desire', name of weave

doch
embroidery (Baloch)

dumchi
trapping for a horse

ezar
loose trousers

falsa or *pharvo*
purple berry (*Grewia asiatica*)

gaan
the edge or piping used to fortify an embroidery

gaani
adornment for a camel's neck

gaj or *adh gaj*
blouse front or small blouse front

ghagro or *parho*
gathered skirt tied with a drawstring

ghughri
bell

ghunghat
veil

ghungroo or *ghungroo-bhart*
bell-shaped embroidery

giichi
embroidered blouse front

gobi jo phul
cauliflower

godiyoon
adornment for a camel's knees

golharo
(*Coccinia indica*) white flower

gontri
fine zigzag stitch

goonde
tassels for a bride's veil

gorbandh
adornment for a horse securing the saddle

gota
woven gold wrapped thread ribbon

gul
flower

gulo
flower motifs on a *ralli: chau* (four), *ath* (eight) or *nau* (nine)

gulbadan
woven pattern

gunchi
short-sleeved blouse

hanno
saddle for a horse

henna
reddish-orange pigment for dyeing hair or decorating hands

hurmitch or *chinnuka*
interlacing stitch

jainamaaz
Muslim prayer mat

jhul
embroidered cloth usually draped over a bullock or camel

jo por; -dublee; -chaunk; -nangei; -kot; -lehr
wooden blocks to delineate areas of stitching named after designs (respectively) round, square, snake, fort or wave

jogis
mendicants

kacho soof
embroidery that relies on a thread-counting technique on the right side of the fabric to create geometric motifs

kakkar
cloud pattern

kamdaani
beaten silver wire sewn on to fabric

kanavez
striped silk used for a *shalwar* (Baloch)

kanbiro
black and white quilted work

kanchali
blouse worn over a skirt

kanchiri, kancholi or *kanjari*
small blouse front

kanjiro or *kanjro*
long embroidered blouse

karhbandhro
broad sash for men

kash
chain stitch (Baloch)

Katcho
hilly area in west Sindh

khatho
woollen shawl

kediyun
Rabari man's tunic

keekar
mimosa flower (*Acacia dealbata*)

kharek
technique in which bars of satin stitches are laid parallel to one another

kheelo
fine interlacing stitches linking panels of fabric

khes
densely woven cotton or silk and cotton fabric used as a spread

kumbhar
potter

kungri
serrated border

kungri bandh
border with circular shapes

kunh
running stitch used in *rallis*

kurta, kurto or *kurti*
straight, loose-fitting tunic

kuto payr
motif of a dog's paw

laadi
a bride

Larh
delta of the River Indus

laroon
orange band on the side of a *gaj*

lehr or *lehrdar*
wave, wave-like

DESERT FLOWERS

The *akhphuli* flower (*Calotropis procera*) in bloom. The bud figures prominently in embroidery from Thar.

The *rohirho* (*Tecoma undulata*) is the most beautiful flower of the desert and has been celebrated in all its embroideries. It is found in yellow, orange, white and a tan brown.

The *golharo* flower (*Coccinia indica*) appears after the rain; it is short-lived and gives way to a bright red chili-like fruit.

The *keekar* or mimosa (*Acacia dealbata*) is a wild tree with thorns whose mustard yellow flowers are ephemeral in nature. The tree is a source of sustenance for livestock, in particular the camel.

loee or *khatho*
woollen shawl

ludi
Rabari wedding shawl

lungi
woven cotton or woven cotton and silk worn as a shoulder wrap or as a turban

maeen pusht
herringbone stitch (Baloch)

maki hanno
adornment for a horse's forehead

maleer
mordant-dyed and resist-printed shawl for men

maniyo waro taunr
circle within a larger circle in a *kanjiro*

marorhi
couched gold- or silver-wrapped thread embroidery

mashru
fabric woven of silk and cotton from the warp of one material and the weft of the other

mehrab or *mihrab*
triangular cut-out in front of caps: indicator in a mosque of the direction of Mecca; the *mihrab* is also replicated on prayer mats

mochi
cobbler or leather worker

mooriyo bandh
a band of embroidery with peacocks

morh
veil for a bridegroom

mor pagla
footprint of a peacock

mosum
fine satin stitch (Baloch)

mukka
beaten silver thread

nali
fine floral embroidery

naqshi
ornamental embroidery with twisted gold- and silver-wrapped thread

nath
leather spread

nehran
a type of embroidery

nohro
coin purse

odhani
married woman's shawl

orak
clan

pabaro
lotus flower (*Nelumbo nucifera*)

pairhan
woman's tunic

paitrho
a short *gaj* cut off above the waist

pakkoh
fortified or dense embroidery

panj soof
motif of five petals

panni
tinsel work

pashk
loose shift (Baloch)

peyti
lower half of a *gaj*

phudo or *pandohl*
long pocket (Baloch)

phul
flower

phulrho
filling stitch or flower motif

phulri
small flower

por
layers of a *ralli*: *mathay jo por* (upper) and *heth jo por* (lower); also a wooden block for printing

posh or *roomal*
dowry cloth or coverlet

pothio
widow's dress

pothu
dowry bag for a groom

punj gulo
five-flower motif

qila or *kot*
fort

raja bandh or *rano bandh*
a row of mirrors outlining embroidery

ralli
quilt

resham
silk

resho
laid and couched stitch

roghan
a resist paste printed on to fabric to highlight elements of the design

rohirho
orange flower (*Tecoma undulata*)

roomal
squares or coverlet

sakhiyo
auspicious symbol for the Hindu god Ganesh

shalwar
loose-fitting or gathered trousers

sheesho
special stitch that attaches mirrors to a fabric

shisho
mirror work

Siro
northern part of Sindh

soof
embroidery using a thread-counting technique in the ground fabric

suraj mukhi
sunflower (*Helianthus annuus*)

surma
beaten, twisted and couched silver-wire work

suthan
loose trouser (Sindhi equivalent of *shalwar*)

tang
camel or horse trapping

tanth
embroidery where stitches are only on the reverse side of the fabric

taro phul
star-shaped motif in embroidery

taunr
fine shells or tassels; also a circle woven on a *kanjiro*

tiki gul
dot and flower motif

tikko
sequins

topi
cap (or hat)

tukwari
appliqué work with pieces sewn edge-to-edge

val
band (literally, vine or creeper)

vanr
tree

Vicholo
central plains of the River Indus

zaat
split stem motif

zanjiro
chain stitch used to delineate motifs from each other

zath
ethnicity or tribe

zardozi
gold- or silver-wrapped thread work anchored on fabric

zeero
knotted stitch

zor
white dots to highlight the outline of a motif

SELECT BIBLIOGRAPHY

Ahmed, Asif Mannan, *A Book of Conquests: The Chachnama and Muslim Origins in South Asia*, Boston 2016

Askari, Nasreen, 'High Roads and Low Roads', in *Textiles from India*, Calcutta 2006, pp. 268–86

Askari, Nasreen, and Crill, Rosemary, *Colours of the Indus*, London 1997

Auj, Nurul, *Legacy of Cholistan*, Multan 1995

Baloch, Nabi Bakhsh (ed.), *The Traditional Arts and Crafts of the Hyderabad Region*, Hyderabad 1966

Boivin, Michel (ed.), *Sindh through History and Representation*, Karachi 2008

Boivin, Michel, and Cook, Matthew (ed.), *Discovering Sindh's Past*, Karachi 2018

Bunting, Ethel Jane, *Sindhi Tombs and Textiles: The Persistence of Pattern*, Albuquerque 1980

Census of India and Census of Pakistan, 1941, 1951, 2017, 2023 et al.

Crill, Rosemary, and Murphy, Veronica, *Tie-dyed Textiles of India: Tradition and Trade*, London 1991

Crill, Rosemary (ed.), *Textiles from India: The Global Trade*, Calcutta 2006

Doniger, Wendy, *The Hindus: An Alternative History*, London 2009

Edwards, Eiluned, *Textiles and Dress of Gujarat,* Ahmedabad 2011

Elson, Vickie, *Dowries from Kutch: A Woman's Folk Art Tradition*, Los Angeles 1979

Fisher, Nora, *Mud, Mirror and Thread: Folk Traditions of Rural India*, Ahmedabad 1993

Gazetteer of Sind, Karachi 1907

Frater, Judy, *Threads of Identity: Embroidery and Adornment of the Nomadic Rabaris*, Ahmedabad 1997

Frater, Judy, 'The Meaning of Folk Art in Rabari Life: A Closer Look at Mirrored Embroideries',
Textile Museum Journal, vol. IV, no. 2, 1975, pp. 47–60

Gillow, John, and Barnard, Nicholas, *Traditional Indian Textiles*, London 1991

Iwatate, Hiroko, *Textiles: The Soul of India*, Tokyo 2007

Khuhro, Hamida, *The Making of Modern Sind: British Policy and Social Change*, Karachi 1978

Markovits, Claude, *The Global World of Indian Merchants*, Cambridge 2009

Nana, Shireen, *Sindh Embroideries and Blocks*, Karachi 1990

Paine, Sheila, *Embroidered Textiles: Traditional Patterns from Five Continents*, London 1990

Panhwar, Mohammad Hussain, *Source Material on Sind*, Jamshoro 1977

Panhwar, Mohammad Hussain, *Chronological Dictionary of Sind*, Jamshoro 1983

Schimmel, Annemarie, *Studies in Sindhi Culture*, Jamshoro 1986

Shah, Deepika, *Masters of the Cloth: Indian Textiles Traded to Distant Shores*, Surat 2005

Sind through the Centuries: Proceedings of an International Seminar in 1975, Karachi 1981